TEA CULTURE OF JAPAN

TEA CULTURE OF JAPAN

Sadako Ohki

with a contribution by
Takeshi Watanabe

Yale University Art Gallery
New Haven

Distributed by Yale University Press
New Haven and London

Publication made possible by the E. Rhodes and Leona B. Carpenter Foundation; Ann and Gilbert H. Kinney, B.A. 1953, M.A. 1954; the Japan Foundation Endowment of the Council on East Asian Studies; and an endowment created with a challenge grant from the National Endowment for the Arts.

First published in 2009 by the
Yale University Art Gallery
P.O. Box 208271
New Haven, CT 06520-8271
www.artgallery.yale.edu

and distributed by
Yale University Press
P.O. Box 209040
New Haven, CT 06520-9040
www.yalebooks.com

**YALE
UNIVERSITY
ART
GALLERY**

Published in conjunction with the exhibition *Tea Culture of Japan:* Chanoyu *Past and Present,* organized by the Yale University Art Gallery.

January 20–April 26, 2009

Tiffany Sprague, Associate Director of Publications and Editorial Services
Christopher Sleboda, Director of Graphic Design

Editor: Joseph N. Newland, Q.E.D.
Map pp. 106–7: Jeffrey Lai
Illustration p. 110: Dustin Amery Hostetler
Set in Adobe Caslon Pro and Futura
Printed at GHP, West Haven, Connecticut

Library of Congress Cataloging-in-Publication Data
Ohki, Sadako.
Tea culture of Japan / Sadako Ohki ; with a contribution by Takeshi Watanabe.
 p. cm.
Published in conjunction with the exhibition, Tea culture of Japan: Chanoyu past and present, January 20–April 26, 2009, organized by the Yale University Art Gallery.
ISBN 978-0-300-14692-9 (alk. paper)
1. Japanese tea ceremony—Utensils—Exhibitions. 2. Art, Japanese—Exhibitions. I. Yale University. Art Gallery. II. Title.

GT2910.O39 2009
394.1074746´8—dc22 2008045796

10 9 8 7 6 5 4 3 2 1

Cover illustration: A tea caddy (cat. 42), napkin, tea whisk, tea scoop (cat. 31), and tea bowl, shown in a traditional Japanese tea arrangement just prior to preparing the tea
Inside covers: Detail of cat. 1a

Reader's Note: Throughout the catalogue, dimensions for tea bowls are given as height by diameter.

CONTENTS

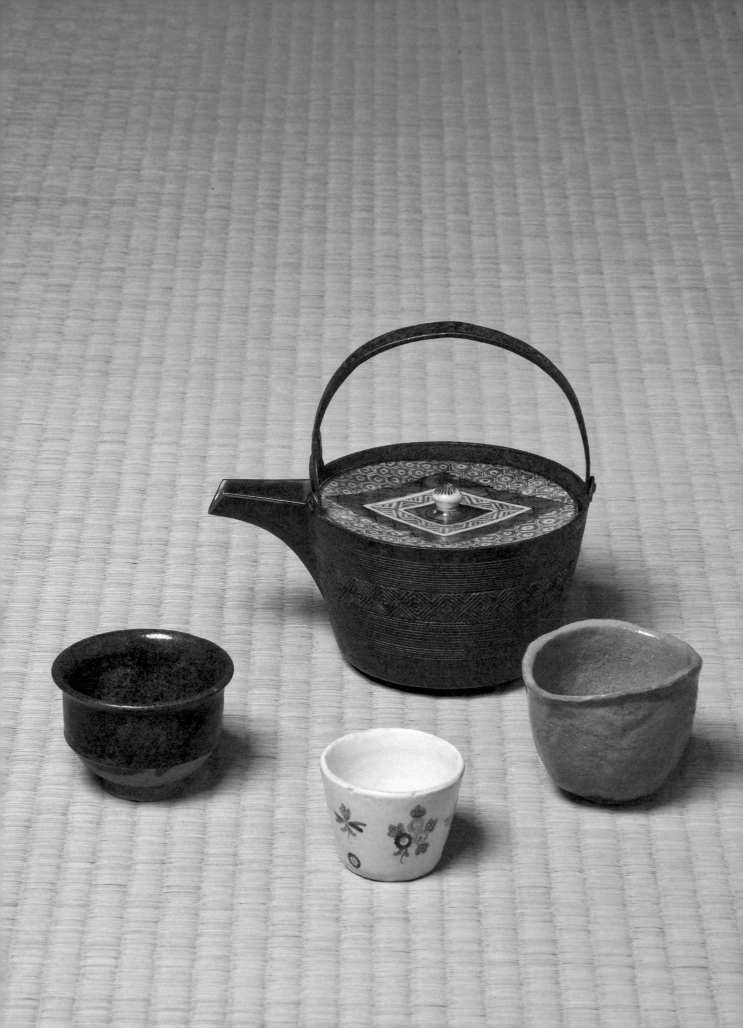

DIRECTOR'S FOREWORD

Opposite.
Clockwise from top: Cats. 71, 82, 75, and 45

IN JULY 2005, 116 WORKS OF ART relating to the tea culture of Japan arrived at the Yale University Art Gallery, on loan from Peggy and Richard M. Danziger, LL.B. 1963. The collectors' expressed wish was that the objects would be experienced directly by students engaged in the study of Japan and Japanese culture. Thus began a period of close examination and documentation of the works—a process that was organized by Sadako Ohki, the Japan Foundation Associate Curator of Japanese Art—and an intense interaction with the art of tea for some very fortunate Yale University students.

The first result of this loan was an undergraduate seminar on the art of tea taught by Mimi Hall Yiengpruksawan, professor in the Department of the History of Art at Yale, in the spring of 2006. Class discussions were enlivened by the presence of guest participants—Dick Danziger, the owner of the collection and a true connoisseur; Takeshi Watanabe, a recent recipient of a doctorate from Yale; and curator Sadako Ohki.

Following this fruitful class, five tea bowls and a screen from the Danziger collection were included as promised gifts in the Gallery's fall 2007 exhibition *Art for Yale: Collecting for a New Century* and were illustrated in the catalogue with accompanying text by Ohki and Watanabe. Watanabe, a contributor to the present publication as well, conducted further research and wrote an article on the five tea bowls for the 2007 *Yale University Art Gallery Bulletin*, which presented important new research by scholars on Japanese art and celebrated the recent and dramatic growth of the Japanese collection at the Gallery. Its success was due in no small part to the notable gifts to the Gallery from the Danziger and Leighton Longhi collections. Major purchases were also made possible by the encouragement and expertise of Professor Yiengpruksawan and the financial support of the Japan Foundation Endowment of the Council on East Asian Studies at Yale.

Further expanding on the foundation the Gallery has built over the past several years to encourage the study and appreciation of Japanese art, our engagement with the Danziger collection has now blossomed into the exhibition *Tea Culture of Japan*: Chanoyu *Past and Present* and this accompanying catalogue, both of which highlight the beautiful objects from this collection. The Danzigers' desire to see the works of art in their collection play a pivotal role in a teaching museum has dovetailed neatly with the Gallery's educational mission to create and enhance opportunities for active learning within the academic community at Yale. *Tea Culture of Japan* has been further enriched by generous loans from other private collections and supplemented by objects from the Gallery's own holdings.

This exhibition and publication examine the importance of Japanese tea culture and the ways in which it has evolved over the centuries. Contrary to popular expectations, not all of the works in the exhibition are Japanese; preparatory research for the exhibition has allowed us to determine that the culture of tea that matured in the sixteenth century in Japan was stimulated by objects from abroad—from China,

Korea, Vietnam, and Europe—and that the arts of tea continue to be responsive to new stimuli as the practice has spread from Japan to other countries. *Tea Culture of Japan* reflects the taste of the various owners and their individual understanding of the art of tea, revealed in the unique combination of objects from the past and the present. It also demonstrates these collectors' keen sensibility in creating a new vocabulary for the beauty of the aged, mended, imperfect, and novel.

The present publication is the first English-language exhibition catalogue to focus on the objects used in the tea ceremony, and it further explores the aesthetics and history of the traditional Japanese tea service, examining the nature of tea collections and the links between connoisseurship, politics, and international relations. It also surveys current practices and settings in light of the ongoing transformation of the tradition in contemporary art and tea houses. Among the cherished objects discussed and reproduced are ceramic tea bowls, bamboo tea scoops, iron kettles, and lacquered incense containers, as well as Zen-inspired calligraphic works.

The inclusive and evolving nature of the arts of tea—from ceramics to textiles, calligraphy to choreographed tea practice, tea house construction to the use of modern images for a *tokonoma* alcove in progressive tea setup—is well illustrated by the exhibition and catalogue, making tea accessible to scholars as well as the general public. Not only students of Japanese art, history, and literature but also those studying issues of globalization, contemporary arts and crafts, and world architecture will find much of interest by visiting the exhibition and reading this publication. Since Japanese tea is an active form of art, tea ceremonies will be performed at the Gallery by prominent tea specialists from Japan, and the public will have a chance to experience the physicality of the art. We are particularly grateful for support from the Council on East Asian Studies at Yale and the Tōdai-Yale Initiative, which has made possible an international symposium on tea that will be held in April 2009. Such activities give deeper meaning to the exhibition.

Both the exhibition and publication received generous support from the E. Rhodes and Leona B. Carpenter Foundation; Ann and Gilbert H. Kinney, B.A. 1953, M.A. 1954; the Japan Foundation Endowment of the Council on East Asian Studies; and an endowment created with a challenge grant from the National Endowment for the Arts, and we are grateful for their help in making this project possible.

Long after the exhibition is over, the present catalogue will continue to provide a comprehensive history of Japanese tea culture, including twenty-first-century practice, and offer rich visual aids illuminating a wide array of tea utensils. *Tea Culture of Japan* will serve as an important tool for those who wish to attain a deeper understanding of the art of Japanese tea.

Jock Reynolds
The Henry J. Heinz II Director
Yale University Art Gallery

ACKNOWLEDGMENTS

IN OUR DESIRE TO CREATE a natural tea-house setting for the exhibition *Tea Culture of Japan*: Chanoyu *Past and Present* at the Yale University Art Gallery, we decided to display as many of the small and large tea-related objects as possible without glass cases. This decision was not easy; apart from the obvious conservation concerns, our display style promised to become a nightmare for the Gallery's security guards. Yet, we received active support and encouragement from Peggy and Richard M. Danziger, LL.B. 1963, who so generously loaned many of the beautiful objects to the exhibition, to step away from the usual cased-museum look and re-create a natural tea environment in which to display their outstanding collection.

Excellent collections in New York and New England have also enriched this exhibition. I am grateful to the Harvard University Art Museums and Mrs. Mary Griggs Burke for their key loans of *karamono*, or Chinese tea objects, and to the Barnet and Burto Collection for their splendid calligraphic pieces. Lee Lee-Nam's video is on loan from KooNewYork; how appropriate it is to see a modern Korean ink painting in digital format become the harbinger of a modern tea arrangement— so reminiscent of the time when the Ido tea bowl introduced a new *sōan* grass-hut-style tea. David Drabkin, LL.B. 1968, Kōichi Yanagi Oriental Fine Arts, and the David and Eleanor Apter Collection provided other generous loans, and an anonymous loan from New York of a portable tea-room structure plays a pivotal role in the exhibition.

My deep gratitude goes to Mimi Hall Yiengpruksawan, professor in the Department of the History of Art at Yale, for her course on tea in the spring of 2006, which brought academic attention to tea culture at Yale. This course was the beginning of a fruitful period of Japanese research and study at the Gallery, of which the present exhibition and catalogue are the culmination. *Tea Culture of Japan* greatly benefitted from the help of Takeshi Watanabe, a recent recipient of a doctorate from Yale University in Japanese literature, who contributed keen research and writing; his training in tea was invaluable to the project. Additionally, we both owe a great deal of gratitude to those scholars whose work preceded our own research at Yale.

At the Gallery, the present exhibition and publication could not have been possible without the constant and conscientious help of my colleagues in the Department of Asian Art: David Ake Sensabaugh, the Ruth and Bruce Dayton Curator of Asian Art and head of the department, and Ami Potter, Museum Assistant. Their daily support took many forms, including editing my peculiar English and attending to logistical details, both big and small.

Tiffany Sprague, Associate Director of Publications and Editorial Services, orchestrated the intricate publication details, with the help of her editorial assistant, Zsofia Jilling. The catalogue essays acquired higher clarity and style after the conscientious editing by Joseph Newland and by a friend of mine, Rose Lee.

Christopher Sleboda, Director of Graphic Design, created a handsome design for the publication.

The Gallery's Digital Media Department, headed by John ffrench, Associate Director of Visual Resources, took hundreds of images of the tea objects, and my thanks go especially to Janet Sullivan, Assistant Manager of Digital Media, and to senior photographers Anthony DeCamillo and Richard House. Photographer Christopher Gardner also took indispensable images of the Danziger collection. The work of this team was augmented by several loaned images from the Japan Society, New York. Carol DeNatale, Director of Collections and Technology, Thomas Raich, Associate Director of Information Technology, and Tim Speevack, Data Systems Specialist, collaborated to develop a special web portal for the Danziger collection that allowed the Danzigers to view the data and images that were generated in the course of cataloguing these objects for exhibition and publication.

Jeffrey Yoshimine, Associate Director of Exhibitions, and Clarkson Crolius, Exhibitions Production Manager, guided me through the complicated realities of an installation that sought to create a natural setting. Thanks go to the special carpentry executed by senior museum technicians Peter Cohen and David Norris, who worked with the sharp design by Yasuo Ohdera of Jin Woodscapes, in Hamden, Connecticut, to evoke traditional Japanese architecture. I am also grateful to Takaya Kurimoto of Penguin Environmental Design, also in Hamden, for the stone arrangement and to Hiro Odaira of Precious Pieces, in New York, for making the *washi* paper title for the exhibition. Senior conservator Patricia Sherwin Garland and object conservator Carol Snow assisted me in determining how best to add greenery to the stone garden while ensuring the safety of the objects in the gallery. The installation crew, led by Burrus Harlow, Associate Director of Installations, has done a superb job, as usual; senior technician Nancy Valley, in particular, understood my vision for the installation. Registrar L. Lynne Addison and senior associate registrar Amy Dowe have so smoothly and efficiently arranged the back-and-forth journeys of the objects. I am sincerely grateful as well for the cooperation and support of John Pfannenbecker, Chief of Security, and to his team for their special vigilance; our mixed-media open-style display would not have been possible without their help.

The tea ceremony that will be presented at the Gallery and the related symposium in the spring of 2009 give life to an otherwise static display. Thank you to all of the participants in these events: Terunobu Fujimori, Christine Guth, Samuel C. Morse, Akira Nagoya, Hiroko Nishida, Sō-oku Sen, Isao Setsu, Shirō Tsujimura, and the Yale students who will help with translations. I also wish to thank Abbey Newman and all of her assistants at the Council on East Asian Studies. The Council, directed by Haun Saussy, enthusiastically funded the symposium with the cooperation of the Tōdai-Yale Initiative. Thanks also go to the Gallery's Business Office, headed by Louisa Cunningham, Deputy Director for Finance and Admin-

istration, including Charlene Senical, Assistant Business Manager. Anna Hammond, former Deputy Director for Programs and Public Affairs, and Elizabeth Harnett, Programs Coordinator, orchestrated the special programming for the exhibition; Jill Westgard, Deputy Director for Museum Resources and Stewardship, and Brian McGovern, Assistant Director of Museum Resources and Stewardship, worked on the funding; Ana Davis, Associate Director of Public Information, took care of the publicity; and the Education and Visitor Services Departments helped organize the public tea performance to provide a rich educational experience to students, scholars, and the public alike. Without our volunteers from New York City, we would not have been able to present this tea service for the public; I am grateful to Ito-san, Kuchiki-san, and Ise-san.

At Yale University's Sterling Memorial Library, Ellen Hammond, Curator of the East Asia Library, and Haruko Nakamura, Librarian for the Japanese Collection, gave unfailing support in searching for books for research and DVDs for film screenings.

Most importantly, I would like to acknowledge Jock Reynolds, the Henry J. Heinz II Director of the Yale University Art Gallery, for his encouragement to pursue my research on Japanese tea art, and Susan B. Matheson, Acting Director, Chief Curator, and the Molly and Walter Bareiss Curator of Ancient Art, for her constant guidance, especially during our director's sabbatical. Thank you to everyone for your tolerance and trust in allowing me to experiment with a new exhibition style that conveys the international code of tea practice. It would only have been possible at an educational institution like ours.

Sadako Ohki
The Japan Foundation Associate Curator of Japanese Art
Yale University Art Gallery

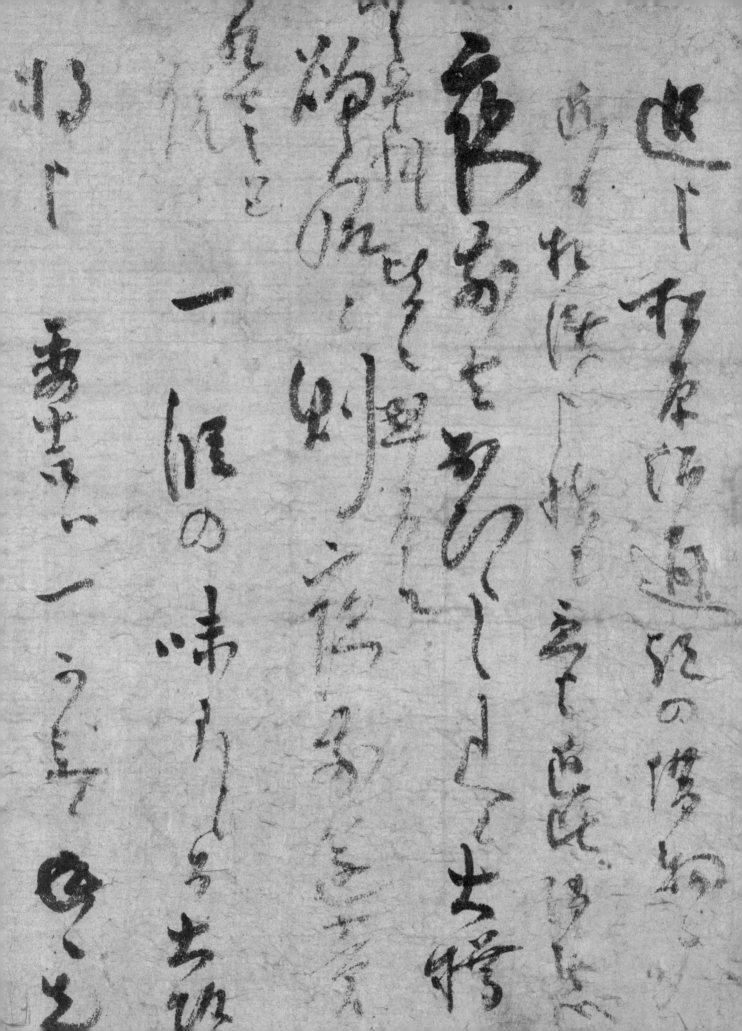

世にわ此四通りの惣物
あれば此れ惣物を
あら是を此事こと云ても色々ある時
魚鳥をもとめてしよく事
鮒鱶など釣
などして魚を
料理して
一通りの味あひをしらすと云事なり
此事
世に云一う事
也

A JOURNEY THROUGH CHANOYU PAST AND PRESENT

Sadako Ohki

Opposite.
Letter (detail), ca. 1583 (see Ohki pl. 1)

CHANOYU, LITERALLY "HOT WATER FOR TEA," refers to a practice of tea that came to fruition in Japan during the sixteenth century. This tea culture and the quintessentially Japanese aesthetic at the heart of its practice, *wabi*, has not only enjoyed continuous patronage in Japan but has also attracted serious practitioners worldwide in our day.[1] The international character of modern *chanoyu* should come as no surprise. Indeed, the distinctive character of Japanese *chanoyu* did not develop in isolation but rather through a creative and continuing process of redefining the tradition by savoring the past as well as drawing in, assimilating, and refining ideas and elements from the wider world. Furthermore, it is an art form that is always in flux, nourished by an ongoing process of evolution and growth.[2]

The practice of *chanoyu* is a dynamic and multidimensional activity that encompasses many art forms and all the human senses. If you experience a small intimate tea gathering as a guest, the cares of the world will start to lift as soon as you walk on the moist stepping stones of a garden, sit at a covered waiting bench (*machiai*), and rinse your hands and mouth at a water basin (*tsukubai*). After you discard social hierarchy by lowering your head to enter the tea room on your knees, as do all the guests, you will feel the texture of the *tatami* mat, admire in the *tokonoma* alcove a hanging scroll selected for you, inhale a whiff of subtle incense, taste a simple but elegant meal from the mountain and sea, and listen to the sound of steam—likened to wind through pine trees—rising from a small opening in the knob of an iron kettle lid. The host of the gathering takes the lid off the kettle, sets it down on a lid rest, and scoops out boiling water that is poured into a tea bowl with powdered green tea, which is then whipped with a bamboo whisk. You observe these carefully choreographed gestures of the host, share in the bowing and the handling of the tea-filled bowl, and finally taste the bitter whipped green tea after finishing a sweet confection.

A full-length tea gathering can last several hours. It starts with a simple *kaiseki* meal before the tea service, which involves the drinking of thick and then thin teas. There is an intermission in the middle, but basically the tea participants share the tight space of the tea room for some time.

It is hoped that this catalogue and the exhibition it accompanies will give you a taste of the complex yet simple *chanoyu* experience through the examination of some treasured tea utensils and paraphernalia. This selection of *chanoyu* implements spans several centuries and cultures, and an array of media ranging from calligraphic works on paper to ceramics, lacquer, bamboo, metalwork, and textiles. Each utensil is highly valued intrinsically for the story it tells about why or how it came to be considered a tea object as well as for the people who made or cherished it on its often long journey through time. Since the larger goal of this project is to explore the ways in which tea culture informs and transforms our lives even today, the purely visual experience of objects in the exhibition will be supplemented with a one-day symposium and a tea demonstration by a tea master to encourage active

participation in the art of *chanoyu*. Preparing tea, a simple act of hospitality, heightens one's awareness of the ambience in which each tea implement comes alive.

The objects gathered in this publication are grouped into three sections. The first, encompassing catalogue numbers 1 through 25, evokes the atmosphere of tea drinking among segments of the warrior class prior to the rise of *wabi* tea (*chanoyu* based on the *wabi* aesthetic) in the sixteenth century, while comprising objects that date after that period. It opens with a group displaying a flamboyant style (called *basara*) followed by a group that shows the development of a more restrained style of tea that was practiced in the temples—called *sarei* ("tea protocol")—and in rooms called *shoin* ("study")—hence called *shoin* tea.[3] The second section (cats. 26–85) features objects from the beginnings of *wabi* tea among the increasingly powerful merchant class shortly before the advent of the grand tea master Sen no Rikyū (1522–1591), and in this section of the exhibition there is a full-scale tea setup.[4] A group of tea scoops, a pivotal implement in *wabi* tea, is featured and discussed in this essay. The third section (cats. 86–96) focuses on *chanoyu* practice in the twenty-first century and its international character. It features a modern tea set with a novel arrangement of tea accoutrements. It also introduces unique tea-related art, some exhibited and published for the first time, that was created or collected especially for the practice of modern *wabi* tea.

The essay in this catalogue by Takeshi Watanabe presents a sweeping overview of the historical development of *chanoyu* in Japan, beginning with the importation of tea from China. The present essay concentrates on the aesthetic dimensions of *chanoyu* after the spread of *wabi* tea as established by Rikyū, with an emphasis on the international and expansive nature of *wabi* tea that is carried on by practitioners, collectors, and artists of *chanoyu* in Japan and abroad today. After examining historical implements and aesthetics, several contemporary artists whose works have entered the realm of *wabi* tea, including Raku Kichizaemon XV, Tsujimura Shirō, Tsuji Seimei, Hamada Shōji, Fujimori Terunobu, and Lee Lee-Nam, are highlighted. To close, four important tea bowls from the fifteenth to seventeenth century that embody the far-reaching and enduring nature of *wabi* tea are discussed.

Wabi tea (*wabicha*) is a uniquely Japanese aesthetic pursuit that was influenced by Zen (Ch. Chan) practice and thought. It emphasizes simplicity, humbleness, and austerity, which can be observed in a calligraphy written by the enigmatic Zen monk Ikkyū Sōjun (see Watanabe essay pl. 14). A similar hanging scroll displayed in a *tokonoma* alcove sets the tone or the purpose of any given tea gathering. The *wabi* aesthetic promotes the appreciation of the plain and the unembellished, with a focus on natural or found materials, exemplified by a ceramic fishing weight used as a kettle lid rest (cat. 34). *Wabi* rouses our positive empathy toward the imperfect and the irregular, perceived in such tea bowls as catalogue numbers 52, 55, 64, and 85. It seeks to set us free from hierarchical order by having us lower our heads without exception in order to enter the tea room through a small entrance. The practice of *wabi* tea encourages creativity and individual expression through the production, collection, and making of arrangements (*toriawase*) of selected tea objects. It fosters the gathering of like-minded friends and the preservation of valued objects, witnessed in the two letters chosen for the exhibition: one written by Rikyū (pl. 1) and the other by Hon'ami Kōetsu (see Watanabe pl. 29).[5] *Wabi* offers compressed and sparse spaces that heighten the appreciation for the full and rich experience of

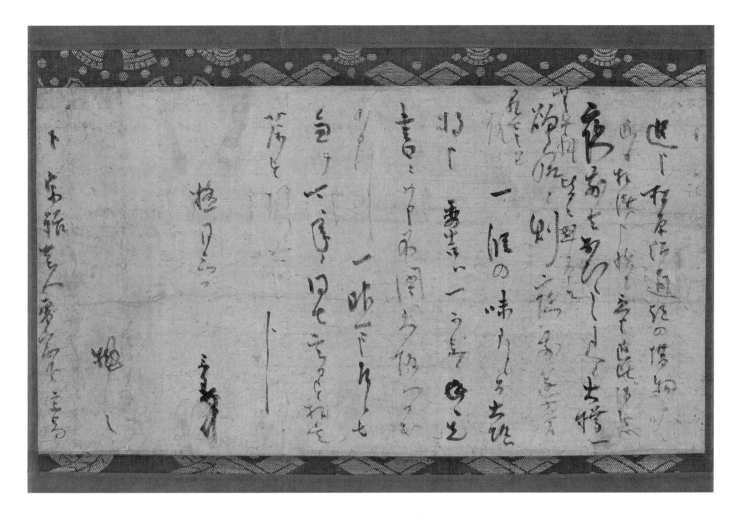

tea. Although it originated in Japan, *wabi* tea is not the possession of one group, one culture, or one country. It is a journey that anyone can take once one adopts *chanoyu* as a part of one's life. [6]

Plate 1.
Sen no Rikyū (Japanese, 1522–1591), *Letter*, ca. 1583.
Hanging scroll; ink on paper, 11 × 20¾ in.
(28 × 52.7 cm). Collection of Peggy and Richard M.
Danziger, LL.B. 1963. Cat. 54

Chanoyu Tea Practice in Medieval Japan: From Extravagant to Sparse

Before the days of Rikyū, daimyo (warlord) tea drinking revolved around extravagant displays of materialistic wealth and pleasure seeking. For example, Sasaki Dōyo (1306–1373), a local warlord in the province of Ōmi (present-day Shiga Prefecture), staged a cherry-blossom-viewing party that lasted from the time the buds formed on the trees until their petals scattered twenty days later. He poured melted copper around the tree trunks to create huge "vases" to simulate the effect of an in situ flower arrangement of the cherries.[7] The term "*basara*" (a Buddhist-derived word meaning "excess" or "extravagance") is commonly used to describe the taste for the outrageous and the electrifying that prevailed among warriors during the fourteenth century. The sumptuous atmosphere of *basara* tea culture is evoked by a pair of six-panel folding screens depicting maple (pl. 2) and cherry trees (see Watanabe pl. 1) from the late seventeenth century and a striking warrior's robe that was once worn by a Nō (Noh) player from the late eighteenth century (see Watanabe pl. 3). At tea parties such as those hosted by Dōyo, warriors shamelessly

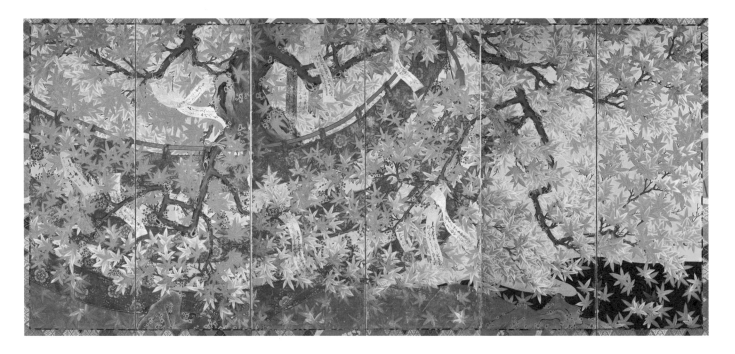

Plate 2.
Maple, from a Pair of Six-Panel Screens: Cherry and Maple, Japanese, 17th century. Six-panel screen; ink, mineral color, and gold and silver pigment on paper, 62 in. × 9 ft. 2½ in. (157.5 × 280.7 cm). Collection of Peggy and Richard M. Danziger, LL.B. 1963. Cat. 1b

sought decadent and ostentatious pleasures. They drank wine to excess, gambled on competitive games such as the identification of tea varietals, hung paintings over gold-ground screens, sat on imported rugs of tiger and leopard skins, wore kimono with wild designs and coats of exotic materials, and displayed expensive and rare Chinese bronze vessels that were obtainable only by the rich and the powerful.[8] The *basara* aesthetic is a precursor to the flamboyant Kabuki culture that later developed among townsmen in the seventeenth and eighteenth centuries. Just as the *basara* aesthetic appeared when power shifted from the nobility (*kuge*) to the military class (*buke*), so too Kabuki culture appeared when townsmen of the merchant class (*chōnin*) expanded their influence and overtook their military rulers in matters of art and culture owing to their greater economic power. During the Edo period (1615–1868), the warrior class would resort to sumptuary laws to control the upstart townspeople, but there was already a hint of rebellion against the establishment in the air during the sixteenth century.[9]

Wabi Inspired by Rikyū

One force behind the revolutionary behavior was Sen no Rikyū, a mere merchant from the commercial town of Sakai (now part of Osaka) who became the head tea master to both Oda Nobunaga (1534–1582) and Toyotomi Hideyoshi (1537–1598). These two warlords, along with Tokugawa Ieyasu (1542–1616), succeeded in unifying the country by the end of the sixteenth century. The practice of tea was often manipulated in the service of unification. When a warlord hosted a lavish public tea party or a small but exclusive one, it was shrewdly done with an eye toward expanding or consolidating his power. Presenting tea utensils as gifts to political allies or even enemies served the same purpose. In the midst of such politics, Rikyū was confident in his personal taste, independent in his mind, and creative in his art and life. He was said to be responsible for introducing the stooping-entrance to the teahouse (*nijiriguchi*), to level hierarchy and leave rank outside the tea hut, which

Plate 3.
Sen Sōtan (Japanese, 1578–1658), *"Hangōken"*
Calligraphy, 1646. Hanging scroll; ink on paper,
20 11/16 × 46 1/16 in. (52.5 × 117 cm). Collection of
Peggy and Richard M. Danziger, LL.B. 1963. Cat. 35

Plate 4.
Furuta Oribe (Japanese, 1543–1615), *Flower
Container*, 1646. Bamboo with gold lacquer repair
and metal pins, 14 3/16 × 4 × 3 7/16 in. (36 × 10.2 ×
8.7 cm). Collection of Peggy and Richard M.
Danziger, LL.B. 1963. Cat. 32

Plate 5.
Attributed to Raku Chōjirō (Japanese, 1516–1592), *Tea Bowl, named Kaedegure* (*Twilight by the Maples*), late 16th century. Black Raku ware; earthenware with black glaze, 3⁹⁄₁₆ × 4¾ in. (9 × 12.1 cm). Promised gift to the Yale University Art Gallery of Peggy and Richard M. Danziger, LL.B. 1963. Cat. 30

Plate 6.
Ceramic Bucket used as a Fresh-Water Jar (*Mizusashi*), Japanese, ca. 1570. Shigaraki ware; stoneware with natural ash glaze, 6¼ × 7¹¹⁄₁₆ in. (15.9 × 19.5 cm). Collection of Peggy and Richard M. Danziger, LL.B. 1963. Cat. 28

demonstrates how rebellious Rikyū was. Yet to have a vaunted tea master like Rikyū as a teacher eventually became too threatening for Hideyoshi, who took preemptive action against the independent tea master and ordered him to commit suicide.¹⁰

Wabi tea and its champion, Rikyū, may be regarded as an antidote to the extravagant excesses of *basara* tea.¹¹ In the present exhibition, the second section is purposely designed to re-create some of the ethos of *wabi* tea as set forth by Rikyū. A life-size portable tea room (*chashitsu*) is installed in the present exhibition, and placed in it and in a waiting bench are the essential accoutrements that go into a traditional *wabi* tea setup (see cats. 26–43).¹² These objects have been selected and arranged to reflect the sparing but refined spirit of *wabi* tea espoused by Rikyū. Such a combination was no longer aimed at showing off the expensive and the exotic but was made to be meaningful for the guest historically, seasonally, and personally. (The host makes a particular *toriawase* fit for each occasion, be it a simple gathering of close friends to bring cheer in the dead of winter or a special gathering to invite the new prime minister of the country to show support for his taking on of heavy responsibility.)

Notable objects in this section are Sen Sōtan's calligraphy scroll (pl. 3), by the grandson of Rikyū who laid the foundation of the Sen family lineages of tea; Furuta Oribe's bamboo flower container (pl. 4; see also pl. 31), to be discussed in detail shortly; a Black Raku tea bowl attributed to Raku Chōjirō (1516–1592; pl. 5, and see Watanabe pl. 20), who started the tradition of unembellished Raku bowls, thought to have first been commissioned by Rikyū; a Shigaraki fresh-water jar, or *mizusashi* (pl. 6), which was originally a container for dye chosen for use as a tea utensil because it exhibits an unpretentious, coarse quality, fit for *wabi* taste; an incense container made from a lacquered-wood nailhead cover from the Jurakudai Palace built by Hideyoshi (see Watanabe pl. 19); and a kettle by Ōnishi Teirin (cat. 36), whose family keeps alive the tradition to this day. Additional tea objects that would fit comfortably into the realm of premodern and modern *wabi* tea are also included in this section (cats. 44–85).

The aesthetic attitudes behind Rikyū's *wabi* tea can perhaps be best illuminated by his extensive use of bamboo as a material of choice for tea implements. Instead of using showy bronze vessels imported from China with a strong foreign flavor (*karamono*)—exemplified by the candleholder with a crane standing on a tortoise (pl. 7) and the incense burner with a lion on top (pl. 8)—Rikyū employed simple vases fashioned from a length of native bamboo similar to the one illustrated here. Flower containers of bamboo for the floral component of *chanoyu* became instantly popular among townsmen. With his radical selection of a "cheap" bamboo vase for his tea practice, Rikyū elevated this material into the *chanoyu* mainstream. In doing so, he added another aesthetic dimension to *wabi* tea. Bamboo was a natural material that brought fresh air into the practice of tea. It was also readily available and grew abundantly in Sakai and the areas neighboring Kyoto and Osaka.¹³ New bamboo flower vases exhibit a fresh, light green color that eventually turns to a light tan, at which time the vases are sometimes lacquered to a rich deep brown. Bamboo vessels dry out with age and often split. In such cases, owners might fit or inlay metal onto them to maintain their function and add to their visual appeal. Such repairs would be lovingly recorded on the lid of the box used to store the vases or as separate colophons on paper. Records of care and ownership for each tea

implement thus become part of its historical identity and enhance its value among tea connoisseurs.

Another inventive use of bamboo in *wabi* tea was in the production of tea scoops (*chashaku*). Rikyū firmly established the practice of carving them and using them in *chanoyu*. Previously, ivory spoons imported from China were used for scooping the powdered green tea (*matcha*) out of the tea caddy (*cha-ire*). The whiteness of ivory feels cool to the eye and to the touch. Its weight is proportionately heavy for its small size, and an ivory spoon makes a sharp sound when tapped against a ceramic tea bowl. A scoop of bamboo, however, is light in weight and emits a softer sound when tapped. Its warm tan color can vary from light to dark depending on the type of bamboo used, or it might be lacquered to a lustrous brown. The color of Rikyū's tea scoop (pl. 9) is derived from the use of dark bamboo.

Today's tea masters carry on Rikyū's practice of carving bamboo tea scoops, using up to a dozen knives of different sizes. The scoops are such a pivotal and personal implement for tea masters that they might carve a number of specimens in their lifetime, each one commemorating or observing a special occasion or life passage.[14] More importantly, bamboo scoops have the potential for individual expression in the small details of their carving, even as the basic shape remains the same. Tea masters' scoops are considered to embody the spirit of their makers and are treasured in much the same way as calligraphies.

Since the time of Rikyū, tea aficionados have written about the beauty of bamboo tea scoops with gusto.[15] There are four included here: the first carved by Seta Kamon (d. 1595), the second carved by Daishin Gitō (1656–1730), the third carved by Kobori Enshū (1579–1647), and the fourth carved by Rikyū.[16] Since these tiny implements seem to embody the very essence of *wabi*, a somewhat lengthy discussion and comparison of three of the four is merited here. These three scoops are illustrated together in plate 10: nearest to the viewer is the scoop by Daishin, the one in the center is by Rikyū, and the one at the back is by Kamon.

When connoisseurs evaluate bamboo tea scoops, they look not only at whether the overall effect is pleasing but also at the telling details of color, thickness, weight, size, workmanship, and the curve and positioning of the joint. The character and creativity of the tea master can often be discerned through his carving of a bamboo scoop. Rikyū's scoop is the darkest in color, the thinnest (the thickest part on the handle measures less than 0.5 cm or 3/16 in.), and the lightest in weight, and it has a sharp yet delicate bend at the joint, which he positioned near the middle of the implement.[17] Although delicate in appearance, the scoop has good "bones." It looks and feels perfectly balanced in the hand. According to a record believed to be inscribed by Rikyū that accompanies this scoop (pl. 11), it was a gift from Rikyū to Suiansai, who is unidentified.[18]

Daishin's scoop, in the front of the group photograph, is the most variegated in color of the three and the thickest (the handle measures 0.9 cm or 3/8 in. at the thickest part, almost double that of Rikyū's scoop). It is the heaviest and has a robust bend at the joint, which Daishin positioned more forward, toward the scooping end of the implement, than did Rikyū. The bowl of the scoop is deep, and its tip is a blunt oblong rather than the more gentle oval profile of the other two scoops. Daishin's is also the sturdiest of the three scoops. When held in the hand, it feels substantial, and the backside shows rough-hewn marks left from the carving

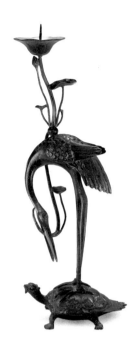

Plate 7.
Candle Stand with a Crane and a Tortoise, Japanese, 15th–16th century. Bronze, H. 15 3/4 in. (40 cm). Property of Mary Griggs Burke. Cat. 19

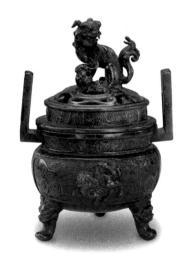

Plate 8.
Incense Burner with a Chinese Lion, Japanese, 17th century. Bronze, 5 11/16 × 3 15/16 in. (14.4 × 10 cm). Property of Mary Griggs Burke. Cat. 23

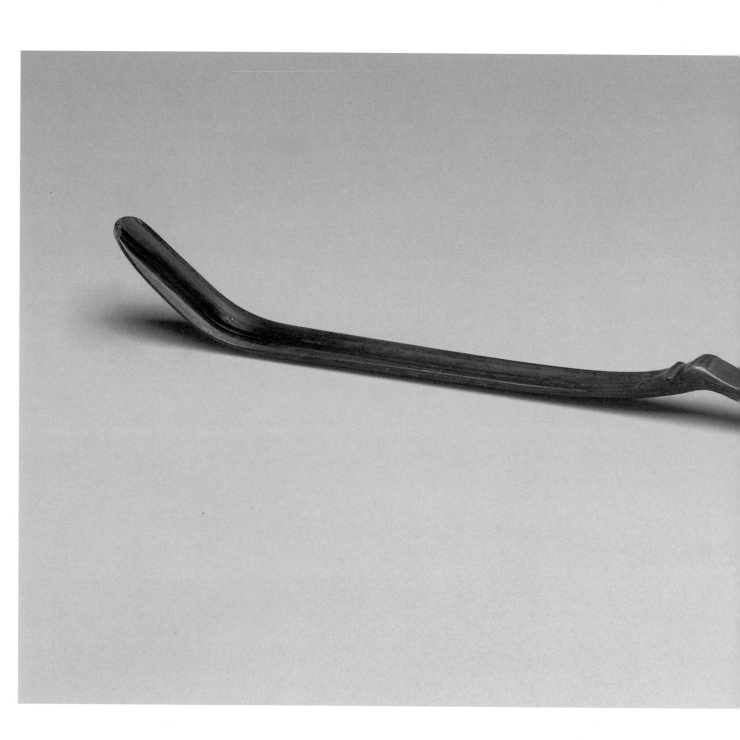

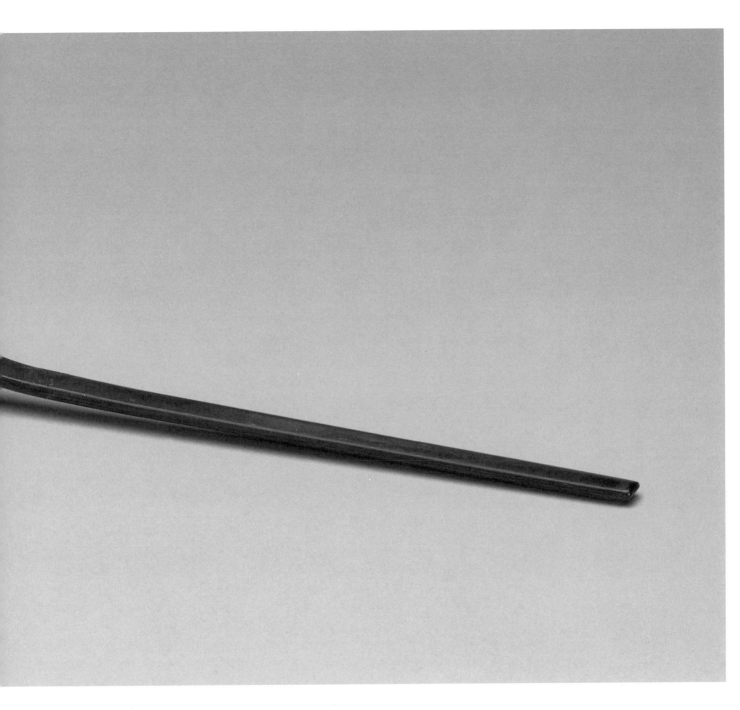

Plate 9.
Sen no Rikyū (Japanese, 1522–1591), *Tea Scoop*, 1580s.
Bent and carved bamboo, L. 7 1/16 in. (17.9 cm).
Collection of Peggy and Richard M. Danziger,
LL.B. 1963. Cat. 31

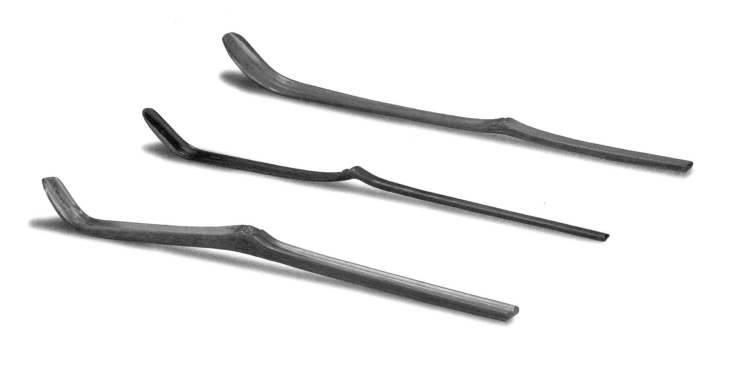

Plate 10.

Front to back: tea scoop by Daishin Gitō (cat. 73), tea scoop by Sen no Rikyū (cat. 31), and tea scoop by Seta Kamon (cat. 58)

knife. Further, it is the only one of the three that was bestowed a proper name.[19] Its name, *Hyakusai*, "One Hundred Years Old," is inscribed on the front of the handsomely carved bamboo container that houses the scoop (pl. 12). The choice of this name by its maker suggests that the utensil was made especially for a recipient who was celebrating an auspicious birthday, perhaps the sixtieth or seventy-seventh one. The style of the carving reinforces the message conveyed in the name: that the recipient live to a sturdy and vigorous one hundred years. An unidentified connoisseur named Mutan wrote a *waka* poem on the inside of the lid to the outer box that houses the scoop and its container. He expressed his admiration for the scoop and his gratitude toward Daishin for putting his whole heart into the carving.[20]

Of the three scoops, the joint on the one carved by Seta Kamon, at the back of the group photograph, has been positioned farthest from the scooping end, further up the handle. The joint itself has a gentle curvature, and when the scoop is placed on its back, it lies almost flat. What distinguishes Kamon's implement from those by Rikyū and Daishin is the large size of its bowl (which measures 1.6 cm or ⅝ in. wide, almost double the width of Rikyū's scoop). Looking at the bowl of the scoop head-on (pl. 13), the carving is sharp and executed without hesitation. The tip is thin and paddlelike. A generous portion of powdered tea can be scooped up in one go with this implement. Kamon reputedly cherished a "broad Korean tea bowl" (*hira kōrai jawan*) with a diameter of over seven inches. Rikyū bestowed the name *Mizuumi* (Lake) on this Korean vessel, so Kamon made a large tea scoop in the shape of an oar to go with the bowl or "lake." The scoop illustrated here, with its large oar-shaped bowl, might very well be the "oar" referred to in the record.[21]

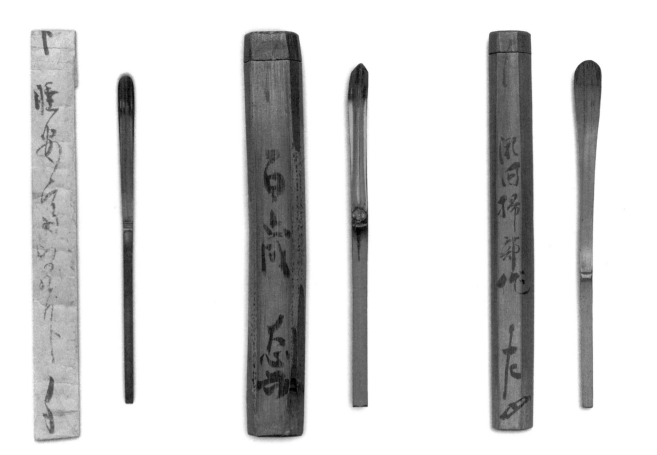

As this discussion shows, tea scoops are not all alike. To the untrained eye they might look similar, but to the *wabi* tea connoisseur each has its own "personality." Daishin's scoop is more robust and hopeful, Rikyū's more delicate yet firm, and Kamon's more relaxed and generous. Once the viewer is attuned to the small details of tea implements, one's appreciation and enjoyment of them will be greatly enhanced.

In addition to utilizing an ordinary and readily available material like bamboo, Rikyū also made use of unlikely objects from near and far in his *wabi* tea practice. The tea bowl is a central implement in the tea service, and until this time, Chinese black Jian-ware (J. *tenmoku*) bowls of sophisticated design, smooth surface, and sharp outline were favored in Japanese tea (pl. 14).[22] Rikyū creatively used Korean Ido pieces as tea bowls (pl. 15; see Watanabe pl. 17 for a view of the foot of this bowl). Thought to have been used for rice in Korea, Ido bowls are generously sized. It was revolutionary for Rikyū and his contemporaries to include these plebeian ceramics with a rustic orange body and rough white glaze into the repertoire of vessels suitable for tea. As was the case with Marcel Duchamp's *Fountain* (1917) when it was first displayed as an art object, Rikyū's contrarian use of vessels like this rice bowl, or a repaired vinegar pourer converted into a tea bowl (pl. 16; see Watanabe pl. 18 for foot), and even salt containers as vessels for *chanoyu* broke many rules of the past. Rikyū's close disciple Yamanoue Sōji said of him: "He made mountains into valleys, west into east, fully breaking the rules of *chanoyu*."[23] Rikyū opened our eyes by making us see old, defective, or crude objects anew. In Rikyū's world, an object imperfect in form or in danger of being thrown away because it is damaged or has no monetary value could very well get a new lease on life and be reborn as

Plate 11.

Sen no Rikyū (Japanese, 1522–1591), *Tea Scoop*, showing paper sheath with inscription believed to be by Rikyū, 1580s. Bent and carved bamboo, L. 7 1/16 in. (17.9 cm). Collection of Peggy and Richard M. Danziger, LL.B. 1963. Cat. 31

Plate 12.

Daishin Gitō (Japanese, 1656–1730), *Tea Scoop, named Hyakusai* (*One Hundred Years Old*), showing bamboo canister with inscription of name by Daishin, early 18th century. Bent and carved bamboo, L. 6 15/16 in. (17.6 cm). Collection of Peggy and Richard M. Danziger, LL.B. 1963. Cat. 73

Plate 13.

Seta Kamon (Japanese, died 1595), *Tea Scoop*, showing bamboo canister bearing later certification of Kamon's name, 16th century. Bent and carved bamboo, L. 7½ in. (19 cm). Collection of Peggy and Richard M. Danziger, LL.B. 1963. Cat. 58

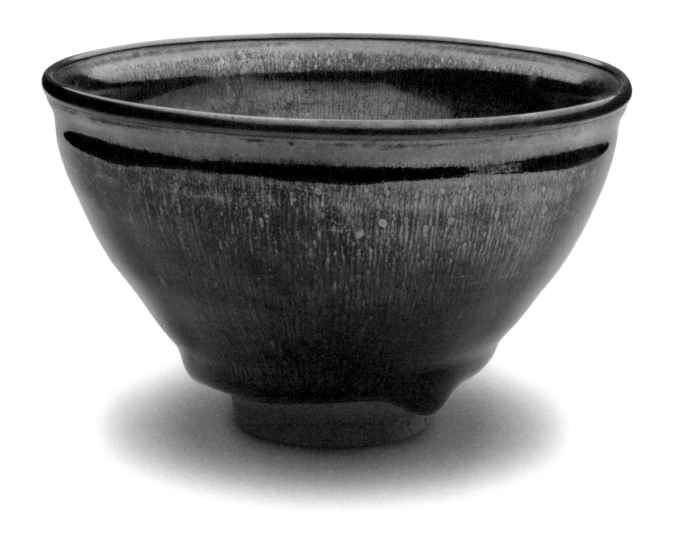

Plate 14.
Tea Bowl, Chinese, 12th–13th century. Jian ware
(J. *tenmoku*); stoneware with dark brown glaze,
hare's-fur markings in iron oxide, and lip banded
with metal, 2⅞ × 5 in. (7.3 × 12.7 cm). Harvard
University Art Museums, Arthur M. Sackler
Museum, Bequest of David Berg, Esq. Cat. 7

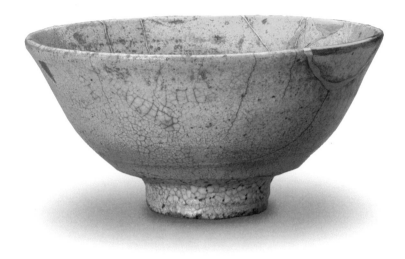

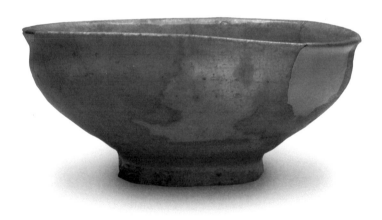

Plate 15.
Tea Bowl, Korean, 16th century. Ido ware;
stoneware with crackled glaze and a fragment of a
Kohiki bowl with gold lacquer repairs, 3 1/16 ×
6 3/16 in. (7.8 × 15.7 cm). Promised gift to the Yale
University Art Gallery of Peggy and Richard M.
Danziger, LL.B. 1963. Cat. 27

Plate 16.
Tea Bowl, Kohiki- or Muji Hakeme–Type, Korean,
second half 16th century. Stoneware with white
slip and transparent glaze with gold lacquer repair,
2 15/16 × 6 5/16 in. (7.5 × 16 cm). Promised gift to the
Yale University Art Gallery of Peggy and Richard
M. Danziger, LL.B. 1963. Cat. 55

a perfect object for *wabi* tea. His sharp sensibility challenged our dull senses to acquire new and fresh perspectives on forgotten, warped and distorted, and cast-off and insignificant objects.

Tea culture in Japan has historically shifted between the taste for the luxurious and pretentious, as exemplified by the *basara* tea beloved by warlords like Dōyo, and the simple and restrained style of *wabi* tea, practiced by Rikyū.[24] Although both tea aesthetics had their heyday, the former in the fourteenth century and the latter in the sixteenth century, both continued to exist side by side throughout Japanese history. While he is best remembered for his austere *wabi* tea, Rikyū taught that the most creative *chanoyu* practice often resulted from harmonizing and mixing disparate elements to form something unique and more meaningful for the anticipating guests. And, of course, it is the guests who are at the heart of a tea gathering.

Twenty-first Century Tea: Continuity and Innovation

Today's *chanoyu* practitioners both in Japan and abroad are fully engaged in continuing Rikyū's tradition of seeking, collecting, and arranging disparate objects, old and new, in artful ways. It is still possible to collect antique tea objects, but interest in modern tea implements has grown rapidly. Many talented artists active in Japan and elsewhere are turning out objects in a spectrum of styles and media expressly for the practice of *chanoyu*. Our third section, emphasizing modern/international *chanoyu*, highlights the works of some of these modern innovators.

Among the contemporary artists who are transmitting Rikyū's innovative spirit is Raku Kichizaemon XV (b. 1949). Kichizaemon makes large, architectonic Raku tea bowls by hand without the use of the potters' wheel and employing only a few simple tools.[25] This method for making Raku bowls was first developed by Raku Chōjirō at Rikyū's request and has not changed much with time.[26] Bowls by Kichizaemon—fifteenth in the Raku lineage—exhibit strong form, produced by sharp angular slicing of the body with a wooden spatula. Parting with Raku tradition at times, they are often glazed with bold combinations of colors: gold, green, yellow, or orange. His wares capture their maker's decisive and exuberant personality, and many share qualities found in modern sculpture. Kichizaemon's training in Western sculptural art comes through in the structure as well as the beauty of his soundly built ceramics.[27] His work is represented here by a gray hanging flower vase textured with firing markings (pl. 17).

Tsujimura Shirō (b. 1947) is another artist who carries on the production of old-fashioned tea bowls infused with Zen-like nonchalance. In fact, Tsujimura has undertaken Zen training, following in the footsteps of Rikyū and many other tea masters. The potter lives and works in the deep mountains of Nara, southwest of Kyoto. His tea bowls have a rustic beauty that perfectly reflects the country house where he cooks mountain vegetables and meat to share with family and friends around a Japanese *ro* hearth.[28] Tsujimura is a thoroughly modern artist who insists on producing tea bowls in the old laborious way. He delights in an earthy and untamed style nurtured by his independent spirit, and he definitely carries on the spirit of hospitality, where the idea of a tea gathering starts.

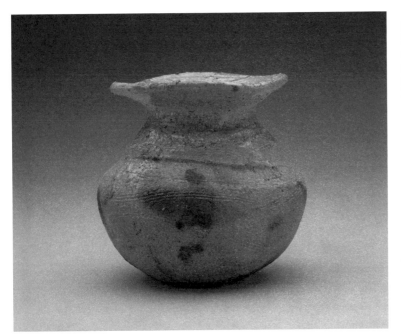

Plate 17.
Raku Kichizaemon XV (Japanese, born 1949), *Flower Vase of Uzukumaru Type*, 1985. Raku ware; unglazed earthenware, 5 1/16 × 4 9/16 in. (12.8 × 11.6 cm). Collection of Peggy and Richard M. Danziger, LL.B. 1963. Cat. 84

Plate 18.
Tsujimura Shirō (Japanese, born 1947), *Tea Bowl*, ca. 2003. Mino-style ware, *hikidashiguro* type; stoneware with black glaze, 3 9/16 × 4 7/8 in. (9.1 × 12.4 cm). Collection of Peggy and Richard M. Danziger, LL.B. 1963. Cat. 85

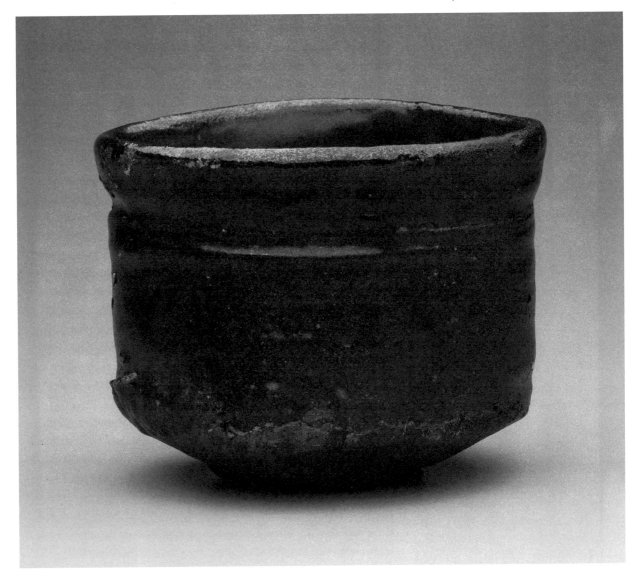

Plate 19.
Tsuji Seimei (Japanese, 1927–2008), *Incense Container (Kōgō)*, 20th century. Iga ware; stoneware with natural ash glaze, 1⅞ × 2¹⁄₁₆ in. (4.7 × 5.3 cm). Collection of Peggy and Richard M. Danziger, LL.B. 1963. Cat. 95

Tsujimura's stylistically carefree ceramics are at times wild and overloaded with earthy incrustations. A *hikidashiguro* tea bowl (pl. 18) that is a fine example of his coarse style is included in the exhibition in a *toriawase* grouping evocative of winter (cats. 46, 56, 64–65, 77, 81, and 85). The bowl displays an uneven black glaze that has collected and smeared toward the bottom near the foot. The warped shape is reminiscent of black Oribe clog-shaped tea bowls.²⁹ A wide lip of about three-quarters of an inch encircles the top of the bowl, and the low foot is almost flat (see Watanabe pl. 21). The bowl may look like it is best appreciated for its strong visual form, rather than functionality. In fact, it is very comfortable in the hand and not heavy. When the snow is falling outdoors, this thick black tea bowl filled with piping hot green tea will not fail to warm both the hands and the body.

Tsuji Seimei (1927–2008) is famous for pioneering the production of ceramic sculpture. His new ideas went beyond the boundaries of conventional ceramic production. He has potted walking sticks, hats, half-opened cans, and boxes. Tsuji broke down the normal expectations of what kinds of objects could be made of ceramic material. He carried on Rikyū's spirit of innovation in his ability to withstand criticism from fellow potters who resisted experimentation with ceramic art. For example, Tsuji astonished many people when he used a saw to cut clay. He championed such new concepts, but as did other ceramic sculptors of his era, he also kept making functional ceramics throughout his lifetime, tea utensils among them. Tsuji's work is represented here by a small Iga-style incense container (*kōgō*; pl. 19), which is included in the exhibition in a setup evoking the international spirit of *chanoyu*.³⁰ The small, five-centimeter-square box with lid exhibits all the fine qualities of Iga ware. Olive-green feldspathic glaze has vitrified and pooled at the top of the lid, while the rough sides of both lid and body show a reddish brown mottled with chocolate-brown and green.

Tsuji's death in the spring of 2008 is one factor in the drawing to a close of the pioneering period of nonfunctional ceramic sculpture in Japan, even as it thrives in twenty-first-century Japan; many young potters, including women, are producing prodigious numbers of ceramic sculptures. Tsuji Kyō, Seimei's wife, who is a noted ceramic artist herself, also produces functional and appetizing utensils for food. Both played leading roles in the ceramic circles of Japan.³¹ Their home and studio is located in Tama, on the outskirts of northwest Tokyo. In conversation, Tsuji once confided to me that he had an ongoing argument with the local fire marshals. The mountain where they built their kiln was once sparsely populated and without nearby neighbors. But suburban sprawl finally reached their property in the last few decades, and they could no longer freely fire up their kiln to produce wares like the small incense container shown here. Even a small tea object like this has a story of its journey in time and space.

Similarly affected by modern urban and suburban life, and the most inspiring among the many sophisticated functioning teahouses built by modern architects, are the "tree teahouses" by Fujimori Terunobu (b. 1946) designed to nest on the tops of tree trunks. The tree teahouses are purposely designed to be tiny and com-pressed spaces in the spirit, if not the style, of Rikyū, in order to experience hyper-reality almost microscopically. Recently published books on teahouse architecture show both the intimate interior spaces and framed exterior views of Fujimori's tree teahouses, such as the Takasugian (fig. 1) and Chashitsu Tetsu (fig. 2), two examples

of the innovative direction that Fujimori is taking in the design of spaces for tea.[32] The photographs show tiny structures perched on top of one or two tree trunks. Each looks and feels like the ultimate form of escape from the crowds and noise of our modern way of life. Yet neighbors live and play just on the other side of these aerial structures. Fujimori's anti-industrial approach to modern teahouses is so refreshing that it causes one to rethink the components of a tea space.[33] All that is needed is a simple room built with natural materials and a symbolic separation from the mundane world. For those living in the concrete jungles of our modern cities, Fujimori's tree teahouses bring back memories of life in simpler eras, when houses still had exposed beams in the ceiling. They also recall the thatched huts (sōan, "a mountain dwelling in the midst of a city") of Rikyū's time.[34] Both offer shelter and escape from the mundane cares and pressures of everyday town life, whether in the sixteenth-century port of Sakai or on the outskirts of Nagano in the new millennium.

In his tiny, irregularly shaped one-room tree houses, Fujimori makes aesthetic reference to the compressed space of Rikyū's two-mat tea hut, the Taian (one mat is approx. 91.4 x 182.9 cm or 36 x 72 in.).[35] Tea practitioners of Rikyū's time were accustomed to larger and more spacious rooms for tea before the master introduced the two-mat space for *wabi* tea. A full-length tea gathering can last several hours, and the participants must share the enclosed area of the tea room for a long while. The space is tight even if there are only one or two guests in addition to the host. Yet Rikyū's Taian was designed with many new features that served to expand the space. Windows were carefully placed to bring in light. Ceilings were cleverly designed to make the room feel larger. The search for compactness in architectural spaces has a long history in Japan.

In contrast to such internationally acclaimed architects like Isozaki Arata, Ando Tadao, and others who have engineered sophisticated teahouses with modern materials and technology, Fujimori made do with simple construction for his first teahouse, the Takasugian (Hut Built Too High). It was built in 2003 on farmland owned by him in Nagano and appears precariously perched on top of two poles. The Takasugian sways in the wind, and its construction does not comply with the strict building codes enacted to protect against earthquakes in Japan. But the idea of a tree-house tea room was so fresh that the architect has received a number of commissions for similar teahouses. The Chashitsu Tetsu (Tea Room Named Tetsu), partly named after Tanikawa Tetsuzō (1895–1989), a philosopher and literary critic who the commissioner of the house wished to honor, is sited among stands of cherry trees in the compound of a museum in Yamanashi Prefecture. The hut was specially built for the purpose of admiring cherry blossoms. Although modern technology was employed to make the footings for this tree house, it was sheer ingenuity on Fujimori's part to disguise this by using "a cypress trunk which extends up into the tea room interior like a backbone. Doing so ensures that the trunk and tea room sway in unison during earthquakes and typhoons."[36]

The most difficult element for modern practitioners of *chanoyu* is the custom of kneeling on *tatami* mats for the duration. Traditional *tatami* mats, made from dried straw left over from the rice harvest, are environmentally friendly flooring, and although the *tatami*, and sitting directly on it, are synonymous with Japanese life, many modern households in Japan are adopting Western-style kitchens and

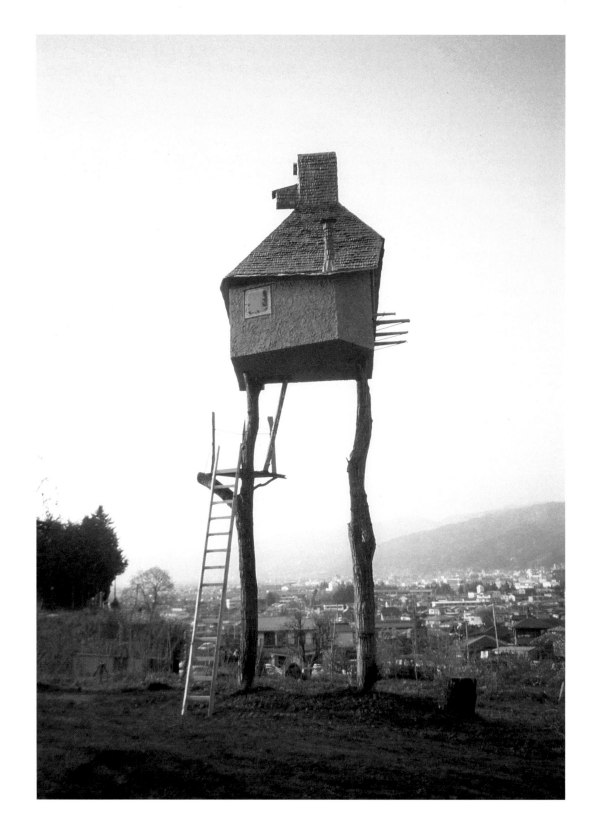

Figure 1.
Fujimori Terunobu (Japanese, born 1946),
Takasugian (Hut Built Too High), Chino City,
Nagano Prefecture, before completion in 2003.
67 sq. ft. (6.24 m²) (floor)

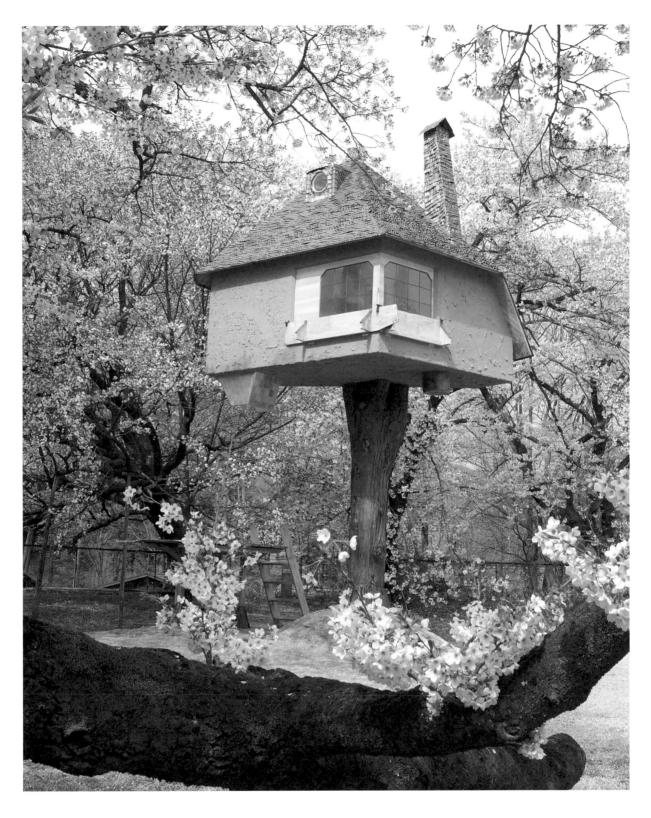

Figure 2.
Fujimori Terunobu (Japanese, born 1946),
Chashitsu Tetsu (Tea Room Named Tetsu), Kiyoharu
Shirakaba Museum, Hokuto City, Yamanashi
Prefecture, before completion in 2005. 65 sq. ft.
(6.07 m²) (floor)

living spaces.[37] *Chanoyu* practice has met the challenge of contemporary life by inventing a new tea service known as *Ryūreishiki*, or standing style.[38] As the name implies, tea is made and served above the floor level. The host makes the tea and the guests drink it while seated in chairs. This *chanoyu* innovation by Sen Sōshitsu (Gengensai) first appeared during the Meiji era in 1872. Now forward-looking tea masters have designed modular setups in the manner of the *Ryūreishiki*-style tea for impromptu tea gatherings in keeping with contemporary lifestyles. The tea service is conducted with both host and guests seated at a table with chairs (fig. 3). This is one of many recent transformations of tea culture. People can now have the experience of an intimate tea gathering with friends and family at home or outside of the home for more formal occasions. The serving of *sencha*, or "steeped tea," does not contain all the multisensory aspects of *wabi* tea. With these new modular structures for "contemporary-style" *chanoyu*, the accoutrements and rituals of traditional *wabi* tea that hark back to Rikyū can be preserved without compromising modern comforts. This accommodation of *chanoyu* to new lifestyles is evident in the choice of the hearth used to make the hot water for tea. Nowadays it can either be an electric stove or an old-fashioned charcoal brazier. Adaptability, practicality, creativity, individuality, and simplicity in the making and drinking of tea, at the heart of the *wabi* tea experience as practiced by Rikyū, are alive and well today in Japan as well as abroad.

Anchoring the third section of the present exhibition are tea objects selected and arranged in the spirit of international and modern *chanoyu*, which appear in

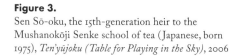
Figure 3.
Sen Sō-oku, the 15th-generation heir to the Mushanokōji Senke school of tea (Japanese, born 1975), *Ten'yūjoku (Table for Playing in the Sky)*, 2006

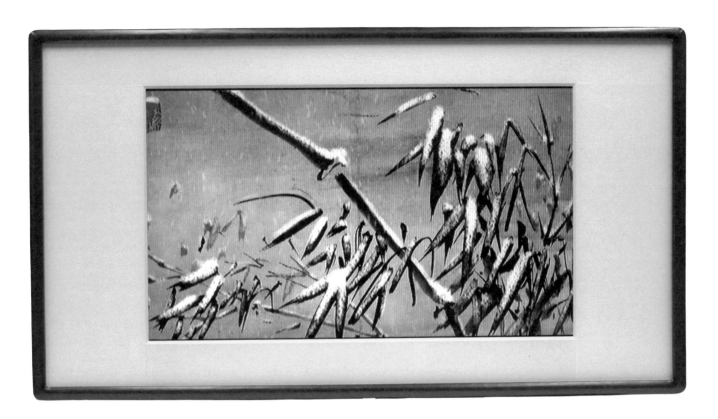

Plate 20.
Lee Lee-Nam (Korean, born 1969), inspired by an original ink painting by Kim Hong-do (1745–1806), *Bamboo in Snow*, 2006. Single-channel video (transferred to DVD) on a 42-in. (106.7-cm) monitor, 3 minutes run time, edition 2 of 6, 30 × 56 × 4 in. (76.2 × 142.2 × 10.2 cm) (with frame). Courtesy of KooNewYork and Lee Lee-Nam. Cat. 96

the gallery in a twenty-first-century setup. Works displayed vertically in the tea setup, if not in a traditional alcove, most often define the space of the gathering. Here we have a video produced in 2006 by the contemporary Korean artist Lee Lee-Nam (b. 1969), entitled *Bamboo in Snow* (pl. 20) after an eighteenth-century ink painting by Kim Hong-do, a celebrated Korean artist of the Joseon period. Lee's three-minute video with soft music that shows a clump of bamboo gently accumulating snow is a great modern adaptation of the *wabi* spirit to which even a restless younger generation may be able to relate. Just as in the poem on a spirited calligraphy hanging scroll by Zen master Zekkai Chūshin (1336–1405; cat. 51) that says "There is no one in the mountain; only a pinecone falling," there is no one in Lee's snowy bamboo. At the end of the video, the bamboo sheds the snow, which, just like the pinecone, makes a faint noise when falling. The meditative atmosphere commands the space. It is appropriate to have a Korean artist's work in a pioneering twenty-first-century tea setup, just as Ido tea bowls from Korea were adopted by Rikyū at an early stage in the development of *wabi* tea.

In contrast to the snowy scene but similarly international in aspect is a rare Okinawan bowl by Hamada Shōji (1894–1978; pl. 21) placed among the modern selections. It is made of brown clay covered with white slip and decorated with underglaze cobalt blue and iron and overglaze green and red enamels. Very likely this bowl was fired at the Tsuboya kiln in Okinawa. An inscription on the inside lid of the storage box states: "overglaze enamel tea bowl made in Ryūkyū kiln."[39] Hamada first visited Okinawa in 1918, with Kawai Kanjirō (1890–1966), another creative ceramist of the Folk Art style. Seduced by the tropical climate and rustic lifestyle, over the years Hamada would make repeated visits to the island during the winter months. In 1920 Hamada accompanied the potter Bernard Leach (1887–1979) to England and built a kiln in St. Ives, Cornwall. After a successful

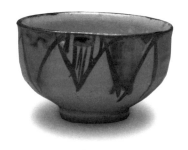

Plate 21.
Hamada Shōji (Japanese, 1894–1978), *Tea Bowl with Okinawan-Style Decoration*, ca. 1930. Stoneware of brown clay with white slip and clear glaze, decorated in underglaze cobalt blue and iron with overglaze green and red enamels, 2¹⁵⁄₁₆ × 4 in. (7.5 × 10.1 cm). Collection of Peggy and Richard M. Danziger, LL.B. 1963. Cat. 93

Plate 22.
Lacquer Stand, Ryūkyū Style, with cat. 90, Okinawan, 16th–17th century. Lacquer on wood with mother-of-pearl, 19½ × 12³⁄₁₆ × 9⅝ in. (49.5 × 31 × 24.5 cm). Collection of Peggy and Richard M. Danziger, LL.B. 1963. Cat. 89

solo show in London in 1923, Hamada returned to Japan and experimented with ceramic techniques in Okinawa before establishing his own kiln at Mashiko in Tochigi Prefecture, north of Tokyo, in 1930. While in Okinawa, he made use of local materials. His enamel red pigment, for example, was made from coral and rice ash, and his cobalt-blue pigment had been ground according to a formula handed down over many generations in one Okinawan family.⁴⁰ The Okinawan landscape also provided inspiration for many of the motifs decorating Hamada's pots.

A pre-1930 date is rare for a work from the hand of Hamada, and comes before he made his signature pieces in the Folk Art style. The shape of the tea bowl is very basic, but Hamada's spontaneous brushwork rendered simply in a bright palette of red, blue, and green makes the form come alive. It has a modern geometric presence, and it took the keen eye of a foreign collector-practitioner of Japanese *chanoyu* to see its potential for tea. In our contemporary setup, we have arranged this unusual Hamada bowl on a red lacquer stand decorated with a design of phoenixes and *qilin* in mother-of-pearl inlay and gold lacquer that dates to the seventeenth century (pl. 22). A red lacquered display shelf similar to this was used as a telephone stand by an American museum director. Here it is utilized as a tea object, and we celebrate the combining of these two pieces from Okinawa in a university town in twenty-first-century America. A white Karatsu fresh-water jar (pl. 23) of the *madara-garatsu* type from about 1600 and embellished with rippling-water marks that suggest the sound of the sea south of Japan is placed on the lower shelf of the stand. It completes a grouping whose goal is to bring objects from different times and places together into a harmonious whole, in keeping with the eclectic and inclusive nature of *chanoyu* practice today.

Our journey through contemporary *chanoyu* comes to rest with an assembly of tea bowls, which, along with tea scoops and tea caddies, are the objects that guests most frequently wish to examine more closely after they finish their tea. Of special note are four tea bowls of the fifteenth to seventeenth century from different Asian cultures. Their stories serve to illuminate our point about the international reach of Japanese tea culture and its creative and eclectic nature. The seventeenth-century stoneware Annamese bowl (pl. 24) with underglaze cobalt-blue decoration has a high, slightly flared, notched foot (*warikōdai*; pl. 25) and bears heavy incrustations on the outside of the foot. In the main decorative field is a design of insects and grasses, and around the mouth is a frieze decorated with rectangular cartouches consisting of fish and the characters for "gold" and "jade" against a background of fish scales. The sides of the bowl slant straight up without bulging out at the foot or flaring at the mouth. This shape is unusual among Vietnamese bowl forms.⁴¹ An inlaid lacquered gold repair on the thick mouth reveals how much this vessel was treasured and used in *chanoyu* despite its damaged state. The inclusion of this bowl, with its unusual shape and design, by American practitioners of *chanoyu* continues the practice begun by Rikyū of respecting the old and the unusual, and underscores the international scope of tea culture.

The tea bowl with dragon medallions (pl. 26) is a Ming Chinese, white porcelain tea bowl of the seventeenth century. It is decorated with a design in underglaze *gosu* blue (an impure asbolite, or cobalt-manganese-iron mixture). Japanese tea aficionados commissioned this type of bowl from the Zhangzhou kilns, located on China's southern coast. After being thrown on a wheel, the vessel was gently

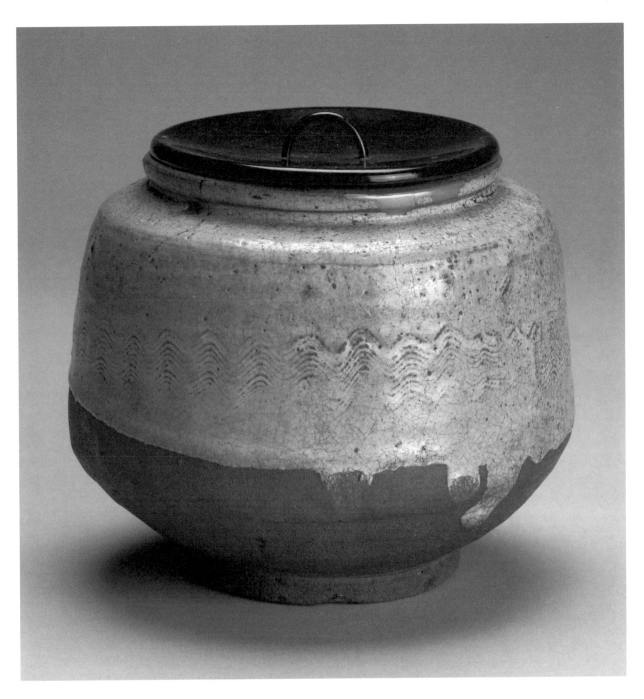

Plate 23.
Fresh-Water Jar (Mizusashi) of Madara-Garatsu Type, Japanese, ca. 1600. Karatsu ware; stoneware with straw ash glaze and gold repair at rim, 5³⁄₁₆ × 4⁵⁄₈ in. (13.2 × 11.7 cm). Collection of Peggy and Richard M. Danziger, LL.B. 1963. Cat. 90

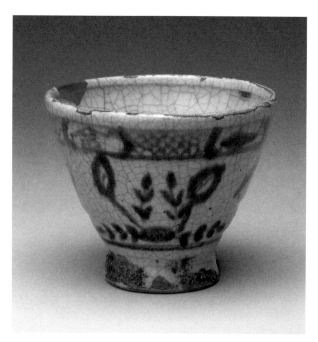

Plate 24.
Annamese Tea Bowl, Vietnamese, ca. 17th century.
Stoneware with glaze and underglaze cobalt-blue
decoration, 3⁹⁄₁₆ × 4½ in. (9 × 11.5 cm). Collection of
Peggy and Richard M. Danziger, LL.B. 1963. Cat. 63

Plate 25.
Foot of Annamese tea bowl shown in pl. 24

manipulated by hand to create the slightly asymmetrical shape that is so appealing
to the *wabi* taste.[42] The potter spurned the use of a high-grade cobalt pigment
for the blue in favor of an impure *gosu* form. The rough, spontaneous brushwork
used in the drawing of the dragon medallions also appealed to Japanese *wabi* tea
connoisseurs' highly developed taste for the appreciation of the insufficient and
the imperfect.

The fifteenth- to sixteenth-century Buncheong-ware tea bowl (pl. 27) is typi-
cal of stoneware from the Korean provincial kilns located within the Gyeryong
mountains, in South Chungcheong Province. The blackish-gray clay body was
loosely brushed with a coating of white slip and then decorated with an abstract
scrolling design in iron-brown pigment, then glazed and fired. Japanese tea con-
noisseurs since the time of Rikyū have been particularly fond of Buncheong ware
with *hakeme* (brushed patterns), in which the slip-coated surface clearly shows
the traces of the brush. The bowl has a few thin lines of repair in gold made by a
Japanese collector. According to an inscription on the box, it was owned by Masuda
Don'ō (Takashi; 1848–1938), a famous tea connoisseur and well-known industrialist
samurai who founded the Mitsui Group, and who had begged the bowl away from
its previous owner, a Mr. Sumii, in the spring of 1928.[43] The bowl is severely warped
in form, and the dynamic brushwork of the chocolate-brown decoration—a styl-
ized design called "dragon bones" (*ryūkotsu*)—carries a strong modern flavor, akin
to some of the symbolic drawings by the Spanish artist Joán Miró (1893–1983). Ma-
suda and his contemporaries had experienced rapid Westernization of Japan begin-
ning in the Meiji era (1868–1912). He might have perceived in this severely distorted
bowl the precariousness of his country, yet its bold decoration is firm and strong,
and might have strengthened his backbone and given him needed encouragement.
Japanese curiosity and sensitivity toward the modern, the international, and the
primitive in art all come into play in the selection of this tea bowl for *chanoyu*.

The Shino example named *Onigawara* (Demon Tile; pl. 28) is a seventeenth-
century bowl with white glaze from the Mino kilns near Nagoya.[44] It shows the

Plate 26.
Tea Bowl Decorated with Dragon Medallions,
Chinese, 17th century. Porcelain with glaze and
underglaze blue, *sometsuke* type, 2⅞ × 5⅝ in.
(7.3 × 14.3 cm). Collection of Peggy and Richard
M. Danziger, LL.B. 1963. Cat. 62

Plate 27.
Tea Bowl, Korean, 15th–16th century. Buncheong
ware; stoneware with slip and iron-brown
overglaze decoration, 3 1/16 × 6¼ in. (7.8 × 15.8 cm).
Collection of Peggy and Richard M. Danziger,
LL.B. 1963. Cat. 52

Plate 28.
Tea Bowl, named Onigawara (Demon Tile), Japanese, early 17th century. Mino ware, Shino type; stoneware with white glaze, 3½ × 5⁷⁄₁₆ in. (8.9 × 13.8 cm). Collection of Peggy and Richard M. Danziger, LL.B. 1963. Cat. 61

Plate 29.
Foot of tea bowl named *Onigawara* shown in pl. 28

Plate 30.
Inscriptions on boxes for tea bowl named
Onigawara shown in pl. 28

Plate 31.
Flower container by Furuta Oribe shown in pl. 4,
showing box with inscriptions

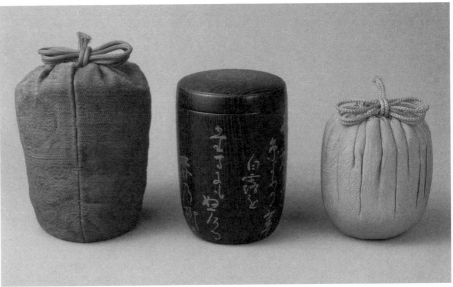

warm white color common to Shino bowls that is derived from the application of white glaze over a reddish-brown clay body. The glaze was unevenly applied, and the surface is covered with small pits, revealing the warm-red clay body underneath. The bowl is shallow and somewhat square in shape. The squarish form is warped and has an uneven lip. The body is carved with a thin horizontal line beneath the lip and another one above the hip. The body surface bears an incised "fence pattern" (*higakimon*) of light vertical lines. The simplicity of this form and the design has a long history of appreciation in Japanese ceramics. The unglazed foot (pl. 29) is square and clearly shows the red color of the clay. The twentieth-century collector Matsunaga Jian (1875–1971) left an inscription on the front of the wooden storage box for the bowl stating that the body surface looks like "a frosty ground" (*shimoji*), but its old name of Demon Tile still prevails. Perhaps the squat, warped form of the vessel along with a surface dotted with small holes and incisions conjures up an image of the large tiles that cap the ends of ridge-beams on roofs; these end-tiles are sometimes decorated with demon masks to fend off evil spirits. A sheet of paper pasted onto the inside bottom of the box (pl. 30) carries an inscription that uses the term "*Shinoyaki*" (Shino ware) to refer to this bowl, which is the earliest known designation of the name *Shino* for this type of ware.

As shown by the discussions of this Shino tea bowl, the Buncheong and Hamada tea bowls, Daishin's bamboo tea scoop, and Oribe's bamboo flower container (pl. 31), the boxes and attached paper colophons that come with old tea implements serve an important function in connoisseurship. In addition, elaborate sets of cloth bags (*shifuku*) are often made for tea implements, and those for an early seventeenth-century tea caddy named *Shira Tsuyu* (White Dew; pls. 32–35) are shown along with the boxes for the caddy here and in the exhibition.[45] The protective and storage containers housing tea objects are textual sites where we find records of the histories, third-party appraisals and appreciations, and repairs of valued tea objects. These textual records add another dimension to the rich experience of *wabi* tea, as the accumulated stories behind the creation and preservation of a tea object are as treasured as its aged beauty.

Plate 32.
Shinbei (Japanese, active late 16th–early 17th century), *Eggplant-Shaped Tea Caddy* (*Cha-Ire*), named *Shira Tsuyu* (*White Dew*), 17th century. Seto ware; stoneware with iron glaze and an ivory lid, 7¾ × 2¹⁵⁄₁₆ in. (19.7 × 7.5 cm). Collection of Peggy and Richard M. Danziger, LL.B. 1963. Cat. 60

Plate 33.
Set of cloth bags and canister for tea caddy named *Shira Tsuyu* shown in pl. 32. *From left*: the cloth bag (*shifuku*) for the protective wooden canister; the protective wooden canister (*hikiya*), inscribed with a poem; and the padded storage bag, the innermost protective covering

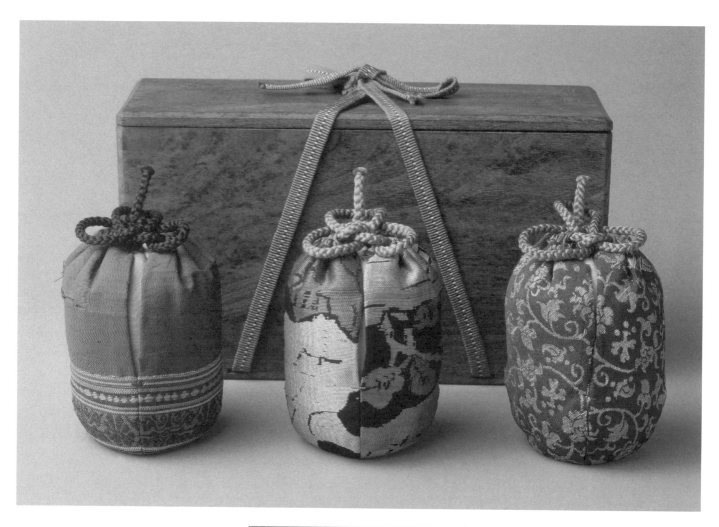

Plate 34.
Inner box for the three display cloth bags (*shifuku*) for tea caddy named *Shira Tsuyu* shown in pl. 32

Plate 35.
Set of storage boxes for tea caddy named *Shira Tsuyu* shown in pl. 32. *Left rear*: the outermost storage box; *left front*: the box for the tea caddy in its storage *shifuku* bags and wooden canister; *right rear*: the outer box for the three display *shifuku* bags shown in pl. 34; *right front*: the paper covers for the two smaller boxes

Our journey through *chanoyu* has taken us through perhaps unexpected expanses of time and space. We made brief stops along the way to take a closer look at some of the treasured objects on display in the exhibition that shed light on the long history and aesthetics of tea culture in Japan. Our journey started with the sumptuous daimyo tea culture of the thirteenth to fourteenth centuries, lingered over the subdued yet complex *wabi* tea practice of Rikyū in the sixteenth century, and closed with the still-evolving modern period of international *chanoyu* in the twenty-first century. In the process, we learned that *chanoyu* is not a static art but rather one that developed in Japan over centuries in a continuous process of selection, elimination, and reinvention. Objects for *chanoyu* were found both at home in Japan and abroad in China, Korea, Vietnam, and farther afield. Today they can be sourced anywhere in our global village. It takes a keen eye to find objects suitable for *wabi* tea. This visual skill may be acquired by taking the time to look closely at the subtle nuances of form, texture, color, placement, and lighting of the tea objects on display, to learn about their history, and to imagine how they might feel in the hand. The training of the mind and eye needed for the assembly and appreciation of tea objects can be transferred to other types of art, whether from Japan or other cultures, and lead to a deeper understanding and enjoyment of them.[46]

NOTES

1 In this essay, written for the general public, the term "*wabi*" is treated as an inclusive term; we are not making close distinctions from, for example, the later aesthetic development such as *kirei sabi* applied to the aesthetics of Kobori Enshū (1579–1647) and Kanamori Sōwa (1584–1656). The tea practice discussed here involves drinking powdered fresh green tea whipped in hot water. Steeped tea (*sencha*) prepared by soaking loose tea leaves in a teapot is the most common way of tea preparation in Japan today (and perhaps in the world, except for tea bags nowadays); it became popular among the literati during the eighteenth century and spread to the public. It forms another tea tradition and is excluded here.

2 There is an interesting parallel between or juxtaposing of two completely opposite currents in the history of Japanese art: insistence on preserving the old and curiosity about the new. Three levels of formalization are often used in classifying Japanese art: *shin*, *gyō*, and *sō*—the most formal, less formal, and the most liberal, respectively. This seems to help those of us who are interested in and dealing with Japanese art and culture to cope with the level of control asserted by traditional formality. Some maintain the tradition firmly, while others are much more open to new, outside stimuli. Even the most conservative artists from families who inherit and preserve artistic traditions that maintain the codified tea practices, such as lacquerers, mounters of paintings and calligraphic works, and cloth-bag makers just to mention a few, tell us it is impossible to carry on the traditions exactly as so many chemical components are now unavailable. See

Senke Jisshoku (*Ten Craft Houses for the Sen Family*), *Tankō bessatsu* (*Tankō Special Issue*) *No. 21* (Kyoto: Tankōsha, 1997), 102–3. This essay takes a liberal approach to the tea tradition.

3 See the sections on "Ceremonial Tea (*Sarei*) at Buddhist Temples" and "Tea and Art Connoisseurship in the *Shoin*" in Takeshi Watanabe's essay, "Breaking Down Boundaries: A History of *Chanoyu*," in this catalogue.

4 Among the many writings on Rikyū, a good background can be found in: Kumakura Isao, translated by Paul Varley, "Sen no Rikyū: Inquiries into His Life and Tea," in *Tea in Japan: Essays on the History of Chanoyu*, ed. Kumakura and Varley (Honolulu: University of Hawaii Press, 1989), 33–69.

5 The letter written by Rikyū in about 1583 reveals that he invited someone identified as Old Man Sōyū, most likely a friend from his tea circle in Sakai, to a tea gathering after he thanked him for the large barrel of tasty sake that he had received and sampled. He mentions in the letter that he would take some to Hideyoshi. For a transcript of the entire contents of the letter, see Komatsu Shigemi, *Rikyūno tegami* (*Letters by Rikyū*) (Tokyo: Shōgakukan, 1985), 359, pl. 57. For an English summary, see Yoshiaki Shimizu and John M. Rosenfield, *Masters of Japanese Calligraphy 8th–19th Century* (New York: Asia Society Galleries and Japan House Gallery, 1984), 192, pl. 74.

6 On *wabi*, see Haga Kōshirō, translated and adapted by Martin Collcut, "The *Wabi* Aesthetic through the Ages," in Kumakura and Varley, *Tea in Japan*, 195–230; and Dennis Hirota, comp. and ed.,

"The Meaning of *Wabi*," in *Wind in the Pines: Classic Writings of the Way of Tea as a Buddhist Path* (Fremont, Calif.: Asian Humanities Press, 1995), 80–92.

7 *Taiheiki*, Book 39, *Shinpen Nihon koten bungaku zenshū*, vol. 57 (Tokyo: Shōgakukan, 1998), 392–95.

8 Many descriptions are recorded in *Taiheiki*, Book 33, *Shinpen Nihon*, vol. 57, 105–6.

9 We could in fact attribute the taste for kitsch among today's youngsters to be a form of resistance against the old norm of producing obedient young students under strict educational codes in Japan.

10 On various theories about Rikyū's death, see the section on "Righting a World Turned Upside Down" in Watanabe, "Breaking Down Boundaries."

11 Rikyū's teacher Takeno Jōō (1502–1555) and his predecessor Murata Shukō (sometimes read as Jukō; 1423–1502) began this trend toward the *wabi* aesthetic. In this essay, Rikyū's name will be invoked frequently to represent the *wabi* aesthetic.

12 The set of objects on display does not follow the strict code of any one school; the portable tea room is an anonymous loan from New York.

13 Bamboo played an important role in Chinese art as well. But while the Chinese literati often sought unusual spotted bamboo for brush handles, for example, the Japanese tended to emphasize the plain materiality of bamboo.

14 Kobori Sōkei, *Kōshin: Kobori Sōkei no sekai* (Tokyo: Sekai Bunkasha, 2006), 122–25.

15 For detailed discussions of tea scoops, see, for example, Nishiyama Matsunosuke, "Meishaku haiken No. 31," *Nihon Bijutsu Kōgei* 478 (July 1978): 74–81; and Nishiyama, "Meishaku haiken No. 33," *Nihon Bijutsu Kōgei* 480 (September 1978): 68–73.

16 Seta was a Momoyama-period warrior and one of seven tea disciples of Rikyū. The monk Daishin was a disciple of Seigan Sōi, a famous Rinzai Zen master. After living at Kōtōin (a subtemple of Daitokuji), he became the 273rd abbot of Daitokuji. Daishin was the Zen master for the Omote Senke tea lineage heir Kakukakusai (1678–1730) and left many pieces of calligraphy and paintings. Enshū was a daimyo official of the Tokugawa shogunate famous for his many talents, including designing and building stone gardens, as well as for his distinctive calligraphic style that followed the style of Fujiwara Teika (1162–1241), a famous *waka* poet and critic.

17 It is said that for his scoops Rikyū employed the bamboo from the ceiling above the *ro* hearth, where soot rose up and turned the bamboo dark (*susudake*). It is also said that Rikyū positioned the joint at the midway point of the scoop, while his teacher Takeno Jōō positioned his joint closer to the bowl of the scoop.

18 Paper *tsutsu* container (referred to as a "bag" [*fukuro*]) inscribed on the front "Suiansai mairu / Eki," or "Goes to Suiansai, [Sō]eki" (Rikyū's priest name), and accompanied by Rikyū's cipher (*kaō*).

19 The fourth scoop in the exhibition was named *Furusato* (Hometown) by Enshū; see Watanabe essay pl. 27. The scoop by Kamon comes in a bamboo cylinder signed by Kakukakusai (1678–1730; Omote Senke VI) authenticating it is by Kamon ("This was made by Seta Sōbu," with Kakukakusai's cipher), but it was not given a name by him.

20 The Japanese poem reads, "Daishin ga / kokoro no take no / saji kagen / yugami nakanimo / sukui torasemu."

21 Hayashiya Tatsusaburō et al., *Kadokawa chadō daijiten*, main volume (Tokyo: Kadokawa Shoten, 1990), 734.

22 Chinese artists most likely worked toward complete control of the outcome of the design and its perfection, but this is not possible to control absolutely, even with a tightly regulated kiln environment and measured glazing. The best quality clay was used for black-ware tea bowls and the foot of each was cut and shaped with great skill. Japanese ceramic artists seemed to have considered the hare's-fur design "too orderly" or perhaps it was technically too puzzling or difficult, and judging from the few works remaining, they seem not to have pursued the effect enthusiastically.

23 Yamanoue Sōji, *Yamanoue Sōji ki, Chadō koten zenshū*, vol. 6 (Kyoto: Tankōsha, 1967), 102.

24 Some may interpret this phenomenon by the two sides of societal use—*omote* (front or public) and *ura* (back or private). For public display, the gorgeous may be used, while for the private, the more humble and comfortable may be used.

25 Raku tea bowls have been made from sandy clay and fired in low temperature without any surface decoration. Their simple shape and style exemplify an austere beauty.

26 Chōjirō is the reputed founder of the Raku family of tea-bowl makers, and his works are the most esteemed Raku wares among tea connoisseurs because of his association with Rikyū. Recent scholarship, however, points to a workshop more than a single person being responsible for ceramics under the name Chōjirō. For further background, see Watanabe, "Breaking Down Boundaries."

27 See Raku Kichizaemon, *Rakuyaki sōsei Rakutte nandarō* (*Creation of Raku: What Is Raku?*) (Kyoto: Tankōsha, 2001); and *Senke Jisshoku*, 56–57.

28 See the catalogue for *Shiro Tsujimura: Clay's Life through Fire Evolves*, Kōichi Yanagi Oriental Fine Arts, New York, May 30–June 20, 2006; and Tsujimura Shirō, "Yashumi afureru utsuwa to chashitsu ni asobu (Having Fun with Utensils and a Teahouse Filled with Wild Taste of Nature)," in *Chanoyu no Susume*, ed. Korona Bukkusu (Tokyo: Heibonsha, 2005), 32–41. This account is also based on the author's visit to Tsujimura's abode, April 20, 2008.

29 For comparisons, see Tokugawa Museum and Gotoh Art Museum, *Chanoyu meiwan: Arataranu Edo no bi ishiki* (*Master Tea Bowls: The Aesthetics of the Edo Period*) (Nagoya: Tokugawa Art Museum; Tokyo: Gotoh Art Museum, 2005), pls. 5–6.

30 Tsuji was known for his interest in tea. See, for example, Sōhen Yamada and Rowland Kirishima, *Sōhenfū Ippuku Ikaga* (Sohen Style: A Way of Tea) (Tokyo: Resonance Co., 2000), 60–75. Another ceramic by Tsuji, a Shigaraki-ware used-water container (*kensui*), is also included in the exhibition (cat. 81).

31 The Peggy and Richard M. Danziger collection includes a number of tea utensils made by Seimei and Kyō, as well as other modern artists, in addition to historical wares.

32 Arata Isozaki, Tadao Ando, and Terunobu Fujimori et al., *The Contemporary Tea House: Japan's Top Architects Redefine a Tradition*, trans. Glenn Rich (Tokyo: Kodansha International, 2007), 82–87, 102–5; and *Fujimori Terunobu, HOME, Special Issue No. 7* (Tokyo: X-Knowledge Co., 2006).

33 Fujimori uses modern technology for securing the base, but his insistence on preserving nature and a natural look in his design is pronounced.

34 Michael Cooper, ed., *João Rodrigues's Account of Sixteenth-Century Japan* (London: Hakluyt Society, 2001), 291.

35 Believed to have been designed by Rikyū and originally built about 1582, the Taian can still be seen in its original form in the Myōkian temple in Kyoto. It incorporated a number of new features to make it feel like a larger space, including the taking in of outdoor light using *shitajimado* (leaving some sections of the plaster wall thin or even open) and *renjimado* (paper panels with thin bamboo strips that cast various shadows depending on the direction of the light), variable ceiling design, and so on.

36 Isozaki et al., *Contemporary Tea House*, 102.

37 The core of some *tatami* today is made from synthetic material to reduce weight and discourage insect infestations.

38 Some argue that the term is no longer valid as the new style is no longer drinking tea while standing but rather while seated at a Western-style stool.

39 "Ryūkyū kama / akae chawan / Shōji [brown seal "Shō"]." For further information, see Susan Peterson, *Shoji Hamada: A Potter's Way and Work* (Tokyo: Kodansha International, 1974).

40 According to notes for this piece recorded by LC (Louise Cort).

41 The closest to this shape that is published is a bowl that was called a "Goroshichi yaki" produced by the potter named Takahara Goroshichi in Hizen near Hirado in Kyushu; his dates are unknown, though he was active toward the end of the Momoyama period in the late sixteenth to early sev-
enteenth century. See *Chanoyu meiwan*, pl. 109. For a similar Vietnamese tea bowl, see *Betonamu Tōji* (Vietnamese Ceramics) (Machida City: Machida Municipal Museum, 1993), pls. 176–77.

42 A similar example with a landscape design, previously owned by the daimyo of Izumo Province, Matsudaira Fumai (1751–1818), a tea master and famous collector of tea utensils, is in the Hatakeyama Memorial Museum of Art, Tokyo. See Hatakeyama Museum, *Yoshu aigan ichi* (Tokyo: Hatakeyama Memorial Museum of Art, 1999), pl. 5.

43 The bowl's wooden storage box has inscriptions by the previous owner, Masuda Don'ō (Takashi; 1848–1938). The box lid obverse reads: "Keiryū / E hakeme / Ryūkotsu" (Buncheong / brushed surface pattern / dragon bone pattern). The interior surface of the box lid reads: "Shōwa 3 nen haru Sumii shi shoji seshi wo shomōshite aizōsu Don'ō, [sealed in cinnabar-red characters] Hekiundai" (1928 spring I begged for this bowl owned by Mr. Sumii, and I've been loving it since it became mine. Don'ō). A piece of paper pasted on one side of the wooden box bears some writing indicating its record number in the collection of Hekiundai (the name of a tea room at Masuda's estate in Odawara) in cinnabar color and then in ink, "Keiryūzan Hirajawan Sumiishi yori [no] bun" (the item from Mr. Sumii, flat tea bowl from Buncheong). The tea bowl is protected by a white, silk drawstring pouch. The box is wrapped in a blue and gray *furoshiki* cloth with South Asian floral pattern and "Hekiundai" (Blue Cloud Highland) in three characters printed in white.

44 "Onigawara" was written in red lacquer directly on the bowl next to the foot, but now the writing has flaked off and is unclear. A paper insert bears the name "Onigawara" accompanied by an impression of the *kaō* of Zuiryūsai (Omote Senke V). A sheet of *washi* paper attached to the reverse of the inner box lid states, "Shino-yaki chawan Zuiryū mei wonikahara nani mo migoto gohizō narubeku sōrō. fugu Kakukaku [*kaō*]" (Shino tea bowl with auspicious name "Demon Tile" is excellent. I do hope you will treasure it. Sincerely, Kakukakusai [Omote Senke VI; cipher]). This is one of the earliest examples of the appellation "Shino-yaki" being used (*Chanoyu meiwan*, 12). The outer box is signed by Matsunaga Jian (1875–1971), a previous owner.

45 For details, see Louise Cort, "Looking at White Dew," *Chanoyu Quarterly* 43 (1985): 36–48.

46 It is not far-fetched to trace back to this *wabi* taste one reason for Japanese success in cultivating new textiles with modern technology by a similar refining process. See "The Globalization of Fabric," *International Herald Tribune*, March 1–2, 2008, Fashion section, 14.

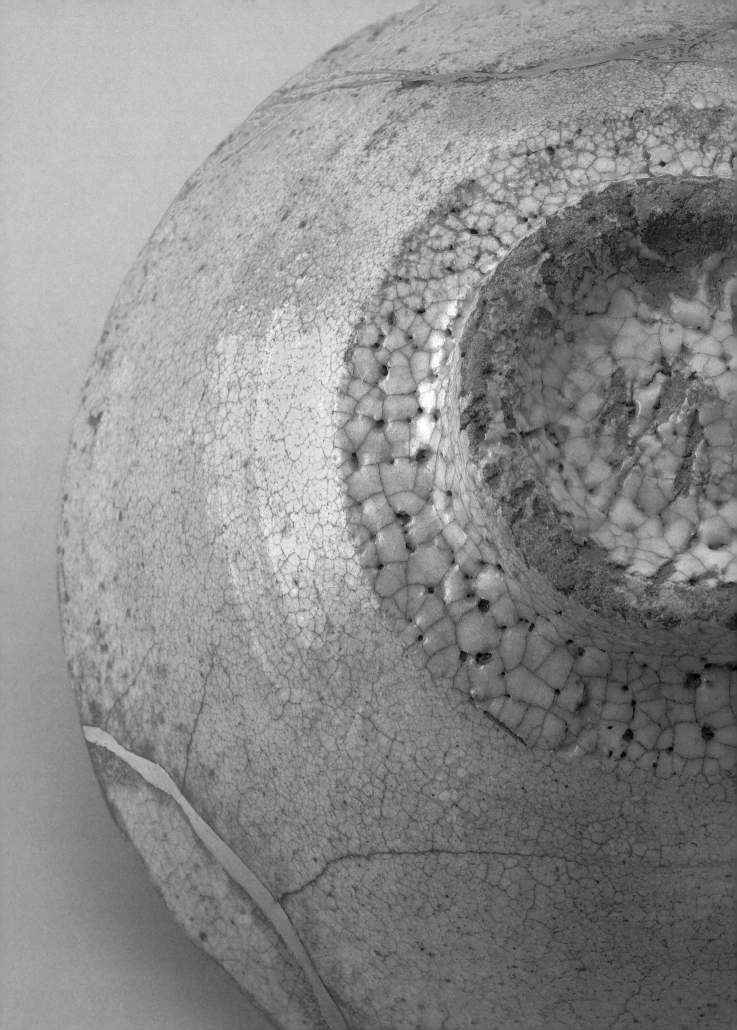

BREAKING DOWN BOUNDARIES: A HISTORY OF CHANOYU

Takeshi Watanabe

Opposite.
Foot of tea bowl (detail), 16th century
(see Watanabe pl. 17)

THE JOURNEY OF TEA STARTED IN CHINA; it first reached Japan in the ninth century. There, especially in the sixteenth century, a quintessentially Japanese cultural practice developed around it—a practice Japanese not only in its aesthetic but also in its fascination with foreign objects and their eventual choreographed incorporation into a unique, native setting. Its history is characterized by diverse figures and vibrant eclecticism. This essay will trace the evolution of tea into a Japanese pursuit, *chanoyu*, literally "hot water for tea," or *sadō*, "the way of tea."

Chanoyu has commonly been translated as the Japanese "tea ceremony," but many practitioners dislike this rendering. "Ceremony" has connotations of a religious ritual, an act divorced from its practical function. As the seminal master of *chanoyu*, Sen no Rikyū (1522–1591), once stated, "*Chanoyu* is just a matter of building a fire, boiling water, and drinking tea."[1] Thus, the mundane act of drinking tea (as well as all that accompanies such hospitable occasions) lies at the heart of *chanoyu*. Rikyū was being somewhat facetious, though, for *sadō* encompasses much more than the tea itself. For any one aficionado of tea—and there were ten million or so at the end of the twentieth century—the path of tea leads to the corporeal as well as the mystical, from the sweets to the hanging scrolls in the alcove imbued with the Zen/Chan spirit.[2] Each practitioner has particular areas that appeal to him or her. At a tea gathering, all of these components come together to make the occasion a special one for the guest.

The following discussion of the Japanese nature of *chanoyu* is therefore not meant to rarefy it as an exotic tradition inaccessible to foreigners. In fact, the diversity of the tea experience and its guiding motivation, hospitality, are universally appreciable. Furthermore, as this discussion of *chanoyu*, its art, and its aesthetics will show, Japanese tea culture has long been an expansive, dynamic tradition that has continually sought out new utensils from Asia and beyond. While some may harbor notions of Japan as being an isolationist, conservative nation, the culture of tea underscores the transnational nature of much of Japanese history, one that may not be so obvious in traditional accounts, colored either by the jingoism of Japan from the eighteenth century that escalated into the 1930s and 1940s or by the orientalist gaze that shaped Western perceptions of Japan from the nineteenth century onward. In the present age, an international interest in tea has injected fresh ideas from other cultures into Japan, just as it had in earlier centuries, when the magical leaf first arrived as part of Chinese civilization.

Tea at the Court of Emperor Saga

The earliest record of tea in Japan dates to 815, when the monk Eichū (743–816), who had spent almost thirty years in China studying Buddhism, served tea to Emperor Saga (786–842).[3] Emperor Saga emulated China's Tang culture at his court, where courtiers recited Chinese poetry while imbibing tea. Some of their

verses celebrate the beverage, associated with Daoist sages who relied on its healing powers. This heavily continental flavor of the early Heian court was overshadowed by the formation of a distinctly Japanese culture over the course of the Heian period (794–1185). While many consider the first imperial anthology of Japanese poetry to be the *Anthology of Ancient and Modern Japanese Poems* (*Kokin wakashū*; ca. 914), *The Anthology from above the Clouds* (*Ryōunshū*; 814), an imperial anthology of Chinese poetry commissioned by Emperor Saga, is older by a hundred years, and it includes poems that refer to tea in the context of banquets at his court. These poems in Chinese were written by Japanese courtiers in Kyoto, but they have, until recently, been overlooked in favor of "purer" expressions of native culture. In the case of tea culture, too, the later, domestic developments have tended to overshadow the transplanted elements, which never disappeared entirely, and in fact continue to exert their influence as an essential foil to the Japanese elements and style.

While Emperor Saga had tea plants cultivated in the palace for enjoyment as well as for court ceremonies, tea did not take root in Japan, literally and figuratively, at this juncture. The tea Eichū brought back from China was a mixture of steamed and fermented tea leaves shaped into a cake or brick (J. *dancha*), which was easily transportable and less perishable than other types of tea. Slivers would be shaved off the brick, brewed, and served with some salt. (Cake and brick tea can still be found in China, especially the famous Puer tea from Yunnan, but related drinking practices are most notably visible in Tibetan cultures, where butter or milk is also mixed into the tea.) Although Japanese courtiers continued to compose Chinese poetry throughout the Heian period, the cultivation of tea seems to have faltered after Emperor Saga's reign, and imported *dancha* (which probably did not taste very good) remained confined to infrequent medicinal use.

Ceremonial Tea (Sarei) at Buddhist Temples

The next chapter in the history of tea in Japan begins with Eisai (1141–1215), a monk who established the Rinzai school of Chan/Zen in Japan. After visiting Song China in 1168 and again from 1187 to 1191, Eisai brought back seeds of the *Camellia sinensis* for renewed cultivation as well as a different form of preparing the beverage. Like Eichū, Eisai served tea to the ruling elite of the time, such as the Kamakura shogun Minamoto Sanetomo (1192–1219), who once when suffering from a terrible hangover was cured by Eisai's administration of tea.[4] Eisai also revitalized use of this beverage through his treatise *An Account of Drinking Tea and Preserving Life* (*Kissa yōjōki*), which extolled tea's medicinal virtues. Although he espoused tea for its practical functions, Eisai's tea also probably tasted better, for he introduced the powdered form of green tea, *matcha*, which the Chinese used during the twelfth century. The drinking of *matcha*, in which powdered leaves are whipped into a hot froth, was continued only in Japan, having been displaced by steeped brews everywhere else.

Taste mattered as tea outgrew its confined role as medicine, but Eisai's success in planting tea in Japanese culture could not have come about without his teaching of Zen Buddhism. In its emphasis on daily, rigorous training and the cultivation of mind, body, and spirit, Zen resonated with the ruling military class,

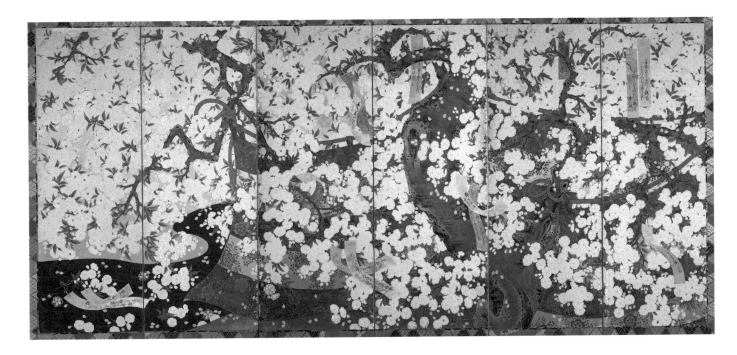

which sponsored the building of large Zen temples where monks would drink tea to relieve fatigue. A set of protocols for handling tea, *sarei*, came to be established at these monasteries. On Eisai's birthday, guests at Kenninji, a major Zen temple Eisai founded in Kyoto, can still see a form of this tea ceremony, called *yotsugashira* (four hosts) *sarei*. Unlike *chanoyu*, in which the host prepares one bowl at a time for each guest, in *sarei*, monks distribute on lacquered stands black *tenmoku* bowls (originally from China) that already have the powdered tea in them. Four monks (the hosts) then bring ewers of hot water and go to each guest, whipping the tea in front of the guest with their left hand.[5] With their lustrous, smooth glaze and symmetrical, conical shape, *tenmoku* tea bowls—represented here by a tea bowl with hare's-fur markings (see Ohki essay pl. 14)—illustrate the early taste in tea utensils in Japan, one that would be radically transformed in the sixteenth century. By elevating the tea bowls, the stands embody the formalism and attention to hierarchy embedded in the *sarei* tradition. Although *chanoyu* evolved along other paths in the subsequent centuries, *sarei* lives on not only at Kenninji but also in the practice of *kencha*, in which tea masters offer the beverage to deities or to the spirits of the deceased at large public services held at Buddhist temples and Shinto shrines.

Basara: An Aesthetic of Ostentation

On such festive occasions, monks invited their neighbors and served them tea in and around the temple precincts. Gradually, in this manner, tea and its ritualized preparation came to penetrate Japanese society. In a late thirteenth-century collection of didactic, popular Buddhist tales, the *Sand and Pebbles Anthology* (*Shasekishū*), a cowherd asks a monk about the beverage he is drinking. The monk explains that tea has three virtues: warding off drowsiness, improving digestion, and inhibiting sexual desire. The cowherd takes off upon hearing the last "virtue," but through this story, we see how tea was entering the consciousness of Japanese society, not only in monastic circles but also among the general population.[6]

Plate 1.

Cherry, from a Pair of Six-Panel Screens: Cherry and Maple, Japanese, 17th century. Six-panel screen; ink, mineral color, and gold and silver pigment on paper, 62 in. × 9 ft. 2½ in. (157.5 × 280.7 cm). Collection of Peggy and Richard M. Danziger, LL.B. 1963. Cat. 1a

As tea grew in popularity beyond the temple precincts, it became a source of entertainment, and in the fourteenth century, a new, opulent aesthetic emerged surrounding this beverage. At extravagant parties that also included rare foods, poetry, and wine, hosts presented tea contests (*tōcha*) in which participants gambled on distinguishing between teas grown in different regions of Japan. Over time, ten different kinds, served in ten rounds for a total of one hundred portions, began to be featured (these contests are commonly described as having "one hundred rounds").[7] Such numbers testify not only to the spread of tea cultivation since Eisai's time, made possible by an increase in agricultural production that allowed for surplus farming of tea, but also to the flamboyant showmanship characteristic among the daimyo of the Muromachi period (1392–1573), in which military warlords vied in battle as well as in wealth and culture.[8]

In particular, Sasaki Dōyo (1306–1373), a provincial lord of Ōmi Province (present-day Shiga Prefecture), was the most notorious of the so-called *basara* daimyo. "*Basara*" refers to an ostentatious, wild, and exotic style (both in attire and life), which Dōyo exemplified. While his decadence may seem contrary to conventional representations of Japanese aesthetics, *basara* illustrates the range of extremes in the tradition. The cherry screen (pl. 1) from the pair of six-panel folding screens in the present exhibition (see Ohki pl. 2 for the maple screen) evokes the famous flower-viewing party Dōyo hosted at Ōharano, in which he presented a hundred-round tea contest. For twenty days, from the cherries' budding to the scattering of their flower petals, Dōyo hosted an unprecedented party in which guests sat on seats covered with tiger and leopard skins, surrounded by gold that made them glitter like a "thousand Buddhas." This description comes from the vivid account found in the fourteenth-century chronicle *The Record of the Great Peace* (*Taiheiki*).[9] Since the narrator is critical of Dōyo's decadence, he no doubt exaggerates for effect. In the end, though, he is aghast even while unable to restrain his amazement. The fragrance of precious, imported incense wafted from celadon censers that hung from curved wisteria branches. It was as though they were, the narrator says, in a grove of sandalwood. Dōyo also poured molten copper around four large cherry trunks to create massive "vases" to suggest that he had arranged the very trees themselves. A military commander, a capable administrator of his domain, and an aesthete, Dōyo was an early master also of incense connoisseurship and of flower arrangement, a tradition that originated in flowers offered at the temple altars that would grow into the art of *ikebana*.

Dōyo was, moreover, adept in linked verse, *renga*, and he played an active role in the compilation of the first imperial anthology of *renga*, the *Tsukuba Anthology* (*Tsukabashū*; 1356), which contains eighty-one of his poems. *Renga*, in which participants took turns composing verses that linked one after the other, exemplified the new, collaborative nature of Japanese culture in the fourteenth century, a trend that accelerated in the fifteenth and sixteenth centuries and was demonstrated in *chanoyu* as well. The monk Tonna (1289–1372) was another prominent member of contemporaneous *renga* circles (see pl. 15 below). Whereas Dōyo acted the part of the *basara* daimyo, Tonna posed as the recluse, a monk who had withdrawn from the mundane world into a realm of poetry and art. Under a canopy of blooming cherries, poets such as Dōyo and Tonna perceived themselves to be at a temporary gateway to another realm, the underworld.[10] We can easily imagine these poets

hanging their poems on the branches of blossoms, dancing in the wind, and creating another world of fantasy, into which these cherry and maple screens draw the viewer. In *renga*, the addition of each new verse shifts the direction of the poem, a characteristic that valorizes each individual contribution and its moment of composition. Symbolized in the ephemerality of the flower, the Zen emphasis on the present moment and the acknowledgment of the irreproducibility of that singular gathering would also find its way into *chanoyu*.[11]

In other seasons, *renga* parties would of course occur indoors, as we see in medieval handscrolls such as the *Illustrated Life of Kakunyo* (*Bokie*; 1351). There, in scroll five, is a *renga* party to commemorate the Man'yōshū poet Kakinomoto Hitomaro (ca. 662–710), whose portrait hangs in the place of honor. While Hitomaro seems to have garnered the most attention in such gatherings, other poets such as Fujiwara Kiyotada (d. 958; pl. 2), who also belonged to the traditional grouping of the Thirty-six Immortal Poets, may similarly have been paid homage. To bestow honor on a lowly poet, who had been a mere servant of the court, would demonstrate the breaking down of traditional hierarchy in novel gatherings such as the *renga* and tea parties that flowered from the late fourteenth to the sixteenth century. To this day, depending on the occasion and the guests, hosts may select such portraits of poets to decorate the alcove at tea gatherings, a tradition dating back to this aspect of medieval parties.

Dōyo acted as an intermediary for another major art form that emerged during the Muromachi period: the Nō drama. The sumptuous robe in the Yale University Art Gallery's collection (pl. 3) exemplifies the costumes worn in this theater. While today Nō conveys an elegant, ritualistic air, its origins lay in agricultural festivals (*dengaku*), street performances with acrobatics (*sarugaku*), and comic routines (*kyōgen*), the last of which now take place in between Nō plays. Some also believe that the stylized movements in Nō derive from the martial arts.[12] Nō costumes generally are made of extravagant textiles and display *basara* style, as does this embroidered robe, for forceful roles such as demons. Dōyo was the first prominent member of the ruling class to recognize the talent of Kan'ami (1333–1384), and his son Zeami (ca. 1363–ca. 1443), who refined Nō into more or less its present form. Besides his plays, Zeami composed numerous treatises on performance that elevated Nō beyond sheer entertainment. Prominent throughout his acting treatises, such as *The Transmission of the Style and the Flower* (*Fūshikaden*) and *The Mirror of the Flower* (*Kakyō*), is the concept of the "flower" (*hana*), which, simply put, symbolizes the charisma of the actor in his temporary, choreographed guise, through which he enraptures the audience and allows it to suspend the mundane world. While there is no evidence of Dōyo's hand in the crafting of this crucial concept, it seems unlikely that they would not have influenced each other, especially considering Dōyo's prominence in flower arranging (*rikka* or *tatebana*, as it was then called). Their relationship is just one example of the nonhierarchical artistic network that existed in Muromachi Japan, through which the arts flourished in new ways.

Dōyo's patronage and his enthusiasm brought Kan'ami and Zeami to the attention of the young shogun Ashikaga Yoshimitsu (1358–1408), who oversaw a vibrant court culture at his Kitayama palace in northwest Kyoto. Like Dōyo, Yoshimitsu was completely enthralled by Zeami's art (his "flower") and made him his favorite. Kan'ami and Zeami were originally from the riverbanks of Kyoto,

Plate 2.
Fujiwara Kiyotada, from the Narikane Version of the
Thirty-six Immortal Poets, Japanese, second half
13th century. Section of a handscroll mounted as a
hanging scroll; ink and light color on paper,
10⅜ × 10⅛ in. (26.4 × 25.7 cm). Collection of Sylvan
Barnet and William Burto. Cat. 47

Plate 3.
Nō Robe, Atsuita Style, Japanese, late 18th century.
Compound twill, brocaded silk, L. in back
57¾ in. (146.7 cm), w. overall 55⅛ in. (140 cm). Yale
University Art Gallery, The Hobart and Edward
Small Moore Memorial Collection, Gift of Mrs.
William H. Moore. Cat. 3

Plate 4.
Octagonal Box, Chinese, ca. 1571. Carved red lacquer with gold and silver pigment, 10 × 11 in. (25.4 × 27.9 cm). Yale University Art Gallery, Anonymous gift. Cat. 21

members of the *kawaramono* social group who resided both geographically and socially on the margins.[13] Presumably, it was to allow them to be in the shogun's presence that they were given names of monks of the Ji sect, which ended in "-ami," though they were not originally affiliated with it.[14] Outfitted in clothes with certain marks or characters (traditionally signaling subordination or discrimination) and bizarre hats that disguised their identities and true social status, *basara* daimyo such as Dōyo cavorted with people in the lower social orders: courtesans, street performers, and merchants.[15] Through his exotic costume and his identity as a monk (rather than as a military governor), Dōyo synthesized an imagined world uninhibited by social norms. This diversity of people, ideas, and objects, choreographed by Dōyo, is at the foundation of all medieval art forms, including *renga*, Nō, and *chanoyu*.

Needless to say, the flouting of social norms and flashy behavior did not go over very well with the government, which was trying to establish order in the capital while consolidating a new ascendancy of the military over the nobles. In 1336 the first Muromachi shogun, Ashikaga Takauji (1305–1358), had issued the Kenmu Code, in which he had criticized the *basara* daimyo: "Recently, *basara* fashion has been used as an excuse to indulge in extravagance and excess, such as the wearing of twill damask and brocade, ornamental silver swords and elegant attire to dazzle the eyes. This has become a mania. . . . In addition, large wagers are made at tea parties and linked verse meetings, and incalculable sums of money are lost in this way."[16] Yet the Ashikaga military leaders were not immune to the expensive pleasures of tea. Indeed, the prizes for the gambling tea contests consisted of precious imported goods newly available through the resumption of trade with China, a policy initiated by Ashikaga Takauji and formalized under his grandson, Yoshimitsu.

Daimyo competed for these Chinese treasures, termed *karamono*, "Chinese things." In 1359, on the seventh day of the seventh month, the day of the Tanabata Festival, Sasaki Dōyo hosted a party in which he succeeded in beating a rival warlord for the company of the shogun. While his rival had proposed a poetry contest of seven hundred rounds, Dōyo promised a formal, seven-piece tea display on a Chinese stand and a seventy-round tea contest with seven hundred *karamono* as prizes, the numbers playing on the date of the festival.[17] Some examples of the type of *karamono* that Dōyo may have awarded are the red lacquer octagonal box (pl. 4); Chinese paintings such as *River Landscape* (pl. 5) after Xia Gui, an artist whose paintings are listed in the Ashikaga collection; and the celadon vase (pl. 6).

Tea and Art Connoisseurship in the Shoin: The Appreciation of Things Chinese

The five major Zen temples of Kyoto (*Gozan*, or Five Mountains) largely managed trade with the continent until the late fifteenth century, for they had been, since the thirteenth century, centers of Chinese learning and culture, including tea. Musō Soseki (1275–1351) was one of the most prominent Zen abbots of his generation and an exemplification of the Gozan culture of this period. He had studied with Yishan Yining (1247–1317), a Chinese Chan master living in Japan, and was intimate with both Emperor Go-Daigo (1288–1339) and Ashikaga Takauji. In fact, some see his influence in the Kenmu Code issued by Takauji, for Musō had a more spiritual view of tea than the tea parties popular at the time and was critical of the corrup-

tion of such ideals. He instead advocated the idea that the drinking of tea equaled Zen practice.[18] His hanging scroll *Poem on the Theme of Snow* (pl. 7) shows not only his Chinese learning in poetry and calligraphy but also an aesthetic that evokes a "chill" that, as we will see, comes to dominate in *chanoyu*, a more spiritual practice than the early, flamboyant tea contests.

Whereas *karamono* had been flaunted as objects of wealth and exoticism, by the generation of the eighth Ashikaga shogun, Yoshimasa 3(1436–1490), such Chinese objects formed the nucleus for a more restrained style of tea that Musō had advanced. In contrast to extravagant parties held at pavilions, tea at Yoshimasa's Higashiyama villa in eastern Kyoto took place in the study of the formal residence. The study, or *shoin*, developed in response to the need to view and to examine Chinese art. This room featured staggered shelves, a display alcove (*tokonoma*) in which to hang Chinese paintings, and a built-in desk by a window, situated in the northeast corner for ideal lighting. Ji-sect monks with artistic discernment (or those of other backgrounds who had the "flower" like Zeami and then assumed monkish names) served Yoshimasa as *dōbōshū*, companions and curators to the shogun. They included actors (Zeami), garden designers (Zen'ami), painters (Sōami), and tea masters (Nōami). Attributed to Nōami and Sōami, the *Register of the Shogunal Family, Left and Right Volumes* (*Kundaikan sōchō ki*; early sixteenth century) provides instruction in the appreciation of Chinese artworks and their proper display. The *Handscroll on Decorating Reception Rooms* (*Zashiki kazari emaki*; fig. 1) is another manual in the same tradition, originally by Mon'a (Mon'ami), who was a master of flower arrangement. Based on such documents, we can see that the desk often featured Chinese utensils for calligraphy, such as our exhibition's inkstone (pl. 8), a brush rest in the shape of mountain peaks (pl. 9), the celadon table screen (pl. 10), and a water dropper with a dragon handle (pl. 11). Chinese Buddhist paintings, the models for Japanese paintings such as Baiken's *White-Robed Kannon* (pl. 12), were usually hung as one of a triptych, accompanied by three objects: a tall candle stand (see Ohki pl. 7), an incense burner (see Ohki pl. 8), and a vase. The *Eight Views of the Xiao and Xiang* (pl. 13) represents another favorite Chinese subject, one that the forefather of the Kanō school, Kanō Masanobu (1434–1530), painted on the sliding doors of the living quarters at Yoshimasa's Higashiyama villa. It was in this context of Chinese art appreciation that *dōbōshū* such as Nōami would exhibit works, light incense, arrange flowers, and serve tea to the shogun and his guests.

Plate 5.
After Xia Gui (Chinese, active early 13th century), *River Landscape* (*Twelve Views of Landscape*), 15th–16th century. Handscroll; ink on silk, 11¼ in. × 17 ft. 3 in. (28.6 × 525.8 cm). Yale University Art Gallery, The Hobart and Edward Small Moore Memorial Collection, Gift of Mrs. William H. Moore. Cat. 16

Plate 6.
Vase in the Shape of a Kundika (Water Container for a Buddhist Altar), Chinese, 14th century. Light gray stoneware with celadon matte glaze, 6⅛ × 1¾ in. (15.6 × 4.5 cm). Collection of Peggy and Richard M. Danziger, LL.B. 1963. Cat. 12

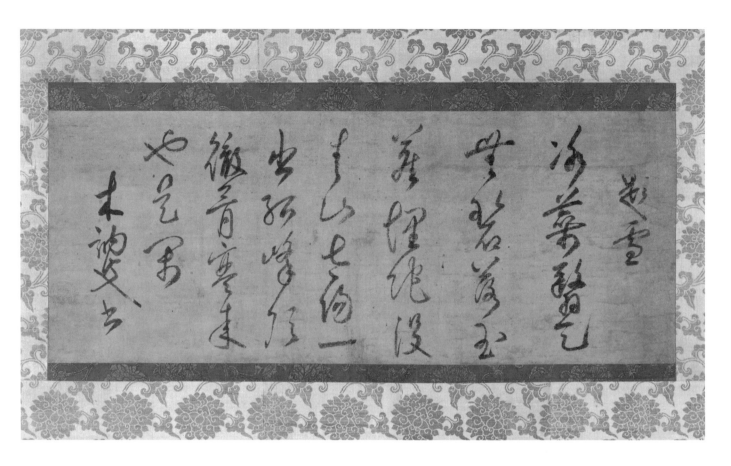

Plate 7.
Musō Soseki (Japanese, 1275–1351), *Poem on the Theme of Snow*, first half 14th century. Hanging scroll; ink on paper, 11¾ × 32½ in. (29.9 × 82.6 cm). Collection of Sylvan Barnet and William Burto. Cat. 49

Figure 1.
Mon'ami (Japanese, active 16th century), *Handscroll on Decorating Reception Rooms* (detail), 1522, copy of 1599. Handscroll; ink and color on paper, H. 11 ⅜ in. (28.4 cm). Kyushu National Museum.
In the center alcove are a triptych of hanging scrolls, in the center front of which are a flower container, an incense burner, and a candle stand in the shape of a crane.

Plate 8.
Inkstone, Chinese, 17th century. Duan stone, 1¾ × 4⅝ × 7⅝ in. (4.5 × 11.8 × 19.4 cm). Yale University Art Gallery, Gift of Robert Hatfield Ellsworth in memory of his mother. Cat. 22

Plate 9.
Brush Rest in the Shape of Mountain Peaks, Chinese, 17th–19th century. Ying limestone with white veining, L. 4½ in. (11.4 cm). Yale University Art Gallery, Gift of Robert Hatfield Ellsworth in memory of his mother. Cat. 24

Plate 10.
Table Screen, Chinese, 14th–15th century. Longquan ware, Tenryūji type; gray-green crackled glaze over brown stoneware, 6 × 6⅝ × 2 1/16 in. (15.2 × 16.8 × 5.2 cm). Yale University Art Gallery, Purchased with gifts from Marianne Gerschel, F. Cheney Cowles, B.A. 1966, and an anonymous donor in honor of Dr. Sadako Ohki. Cat. 13

Plate 11.
Water Dropper with a Dragon Handle, Chinese, late 13th–early 14th century. Qingbai ware; porcelain with glaze, H. 2 5/16 in. (5.9 cm), W. over handle 3⅛ in. (7.9 cm), DIAM. 2⅜ in. (6 cm). Yale University Art Gallery, Purchased with a gift from Alan Kennedy in honor of Schuyler V. R. Cammann, B.A. 1935. Cat. 10

Plate 12.
Baiken (Japanese, active late 15th–early 16th century), *White-Robed Kannon*, late 15th–early 16th century. Hanging scroll; ink on paper, 28 9/16 × 9 15/16 in. (72.5 × 25.2 cm). Yale University Art Gallery, Purchased with funds from the Japan Foundation Endowment of the Council on East Asian Studies. Cat. 18

Plate 13.
Anonymous, with a seal reading Kanō Motonobu (Japanese, 1476–1559), *Eight Views of the Xiao and Xiang*, first half 16th century. Hanging scroll; ink on paper, 17 15/16 × 28 15/16 in. (45.6 × 73.5 cm). Yale University Art Gallery, Leonard C. Hanna, Jr., B.A. 1913, Fund. Cat. 20

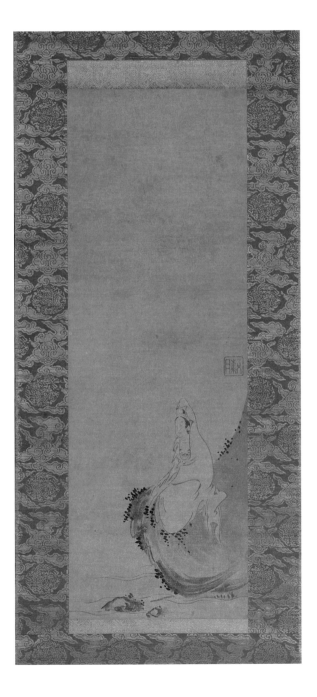

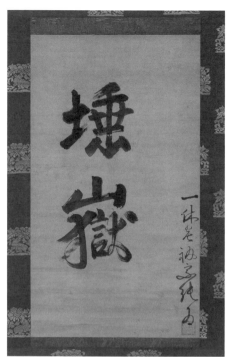

Plate 14.
Ikkyū Sōjun (Japanese, 1394–1481), *Naming Certificate for "Tagaku," by Ikkyū*, 15th century. Hanging scroll; ink on paper, 22³⁄₁₆ × 12¹¹⁄₁₆ in. (56.4 × 32.2 cm). Collection of Peggy and Richard M. Danziger, LL.B. 1963. Cat. 17

Shukō's Sōan Tea: The Beginnings of Wabi Tea

As Akanuma Taka notes, however, the *Register of the Shogunal Family* gives us a picture only of Ashikaga taste, and should not be considered illustrative of the society at large.[19] By the time the shogun's advisors wrote this text, a new aesthetic and its related objects had already begun making their mark. This sensibility was not entirely new in poetry, as we see in the calligraphy of both Tonna and Musō, but it led to a revolutionary way of tea called *wabicha*, "*wabi* tea," or tea of the *sōan* (thatched hut). Murata Shukō (also pronounced Jukō; 1423–1502), was arguably the first proponent of this innovative style. Shukō was born in Nara, and he entered a Buddhist monastery at age eleven. Disillusioned with the monastery, he went to Kyoto in his twenties and became a disciple of Nōami and Sōami. In his thirties, Shukō entered Shinjuan, a subtemple of Daitokuji, where he studied with the famous Zen master Ikkyū (1394–1481).[20] Despite the uncertainty about much of Shukō's biography, his relationships across the social hierarchy (with monks, warriors, aristocrats, and merchants) illustrate the social network within which he created his new vision of tea, under the influence of Zen through the iconoclastic Ikkyū and the connoisseurship of Nōami and Sōami.

Something of Ikkyū's famed eccentricity can be seen in his naming certificate for a disciple named Tagaku, who is otherwise unidentified (pl. 14). In their slightly crooked appearance, the characters with their rhythmic vitality convey an impish spirit altogether in keeping with this Zen master who flouted convention in despising stuffy officialdom and embracing courtesans and sparrows.[21] In conveying the character of the calligrapher, such pieces offer the recipient a memento of his master's spirit, essential for the Zen/Chan tradition, in which great value is placed upon the direct transmission from teacher to disciple. The display of Chan calligraphy in the tea setting is thought to have been started by Shukō, who hung a piece by Yuanwu Keqin (coauthor of the Chan classic *The Blue Cliff Record*; 1063–1135) that was given to him by Ikkyū.[22] When the guest, upon entering the tea room, bows to the scroll decorating the alcove, he or she pays homage and celebrates the spirit behind the brushstrokes and the multiple relationships the scroll embodies between teacher and disciple, giver and recipient, host and guest, and even China and Japan.

Shukō's emphasis on Chan in the scrolls he chose to display in the tea room was accompanied by his influential changes to the setting for tea practice. He took tea out of the formal study and into the *sōan*, a grass-thatched hut that recreated a country retreat within the city. Echoing Tonna's metaphoric escape from the mundane, secular world, Shukō's four-and-a-half-mat room (less than nine feet square) also harked back to Vimalakirti's hut, in which the Indian Buddhist sage welcomed 84,000 heavenly beings. While Shukō's room was of the same floor area as Yoshimasa's *shoin*, the Dōjinsai at the Higashiyama villa, Shukō simplified the interior and envisioned it as a mystical space that in its very constraints transcended time, politics, and geography. Indeed, his tea room broke through boundaries in how tea itself was conceptualized and practiced in terms of aesthetics, utensils, and practitioners.

Although Shukō is credited as the founder of *wabi* tea, he did not, in fact,

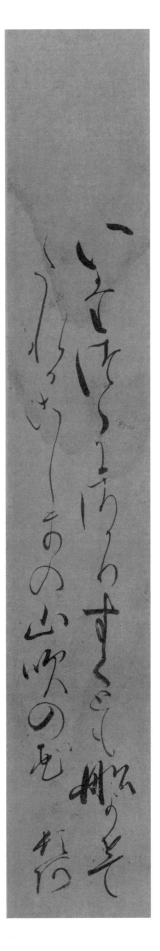

Plate 15.
Tonna Hōshi (Japanese, 1289–1372), *Poem by the Monk Tonna*, mid-14th century. Hanging scroll; ink on paper with blue cloudlike decoration, 14 3/16 × 2 3/16 in. (36 × 5.5 cm). Collection of Peggy and Richard M. Danziger, LL.B. 1963. Cat. 50

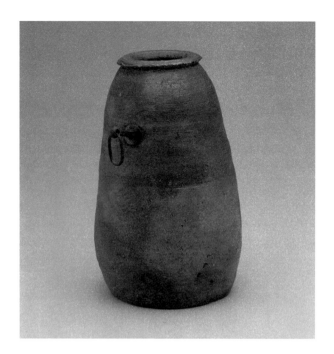

Plate 16.
Hanging Flower Vase, Japanese, 16th century. Old Bizen ware; unglazed stoneware, 6⅞ × 3⁹⁄₁₆ in. (17.5 × 9 cm). Collection of Peggy and Richard M. Danziger, LL.B. 1963. Cat. 53

employ the term "*wabi*" for his style of practice. The concept of *wabi* connotes the beauty of deprivation and was developed first in medieval poetic discourse. Tonna's poem (pl. 15) is an early evocation of *wabi* sentiment: "Who draws their boat to the small island of globeflowers, though forlornly past their prime?" Appreciation of the withered, things past their peak, and the pathos of melancholy define some aspects of *wabi*. Shukō described the effect he sought as "chilled and withered" (*hie kareta*), a characterization that paved the way for *wabi* tea. In his *Letter on the Mastery of the Heart* (*Kokoro no fumi*), Shukō criticized parvenus who tried to achieve the "chilled and withered" effect, which was already then becoming a fad, by procuring rough pieces from Bizen and Shigaraki, old kiln sites in Japan: the Old Bizen hanging flower vase (pl. 16) typifies early Bizen ware and its stony surface, colored by dark modulations. With its irregular, natural ash glaze, the Shigaraki fresh-water jar (see Ohki pl. 6) also demonstrates the stark change in taste away from the smooth, lustrous surfaces of Chinese wares. Shukō instead admonished, "Critical above all else in this way [of tea] is the dissolution of the boundary line between native and Chinese [objects]. This is vital, truly vital."[23] How did Shukō then propose to blur this distinction?

Although the use of tea utensils made out of bamboo is more closely associated with Rikyū and his realization of *wabi* tea and may seem completely Japanese, it also has strong Chinese associations, as Matsuoka Shinpei suggests.[24] Bamboo is a prominent topos in Chan/Zen Buddhism, as well as in Chinese art and poetry. One way Shukō dissolved the boundary was through his pioneering incorporation of bamboo into his *sōan*. Architecturally, he added bamboo accents in the ceiling and the borders of the eaves, for instance. Shukō also began using tea scoops made of bamboo, since he disliked the sound of ivory tea scoops on tea bowls.[25] While the rustic feel of the bamboo, plentifully found around the outskirts of the city or in temple precincts, accorded with the *wabi* aesthetic, it also evoked Chan and its Chinese history.

Shukō's criticism of the parvenus also points to the introduction of the Japanese wares that he in fact precipitated with his new ideas on tea practice. The introduction of Japanese objects was a harbinger of the course *wabi* tea would take in the following century. In part, this developed out of necessity. As Louise Cort observes, "The new aesthetic [Shu]kō promoted was related in its practical aspect to the destruction of old collections and the limited availability of replacements within the capital."[26] Cort alludes here to the Ōnin Wars (1467–77), a devastating series of skirmishes among rival warlords and attendant destruction in the capital, which induced changes in the mentality of its denizens. *Wabi* reflected not only the physical but also the psychological landscape of the late fifteenth century, and early *wabi* tea was in part a practical accommodation to new circumstances. Yet Shukō did not advocate simply presenting coarse Japanese wares by themselves but rather finding a compelling balance. "How engaging is the sight of a fine steed tethered at a thatched hut," he supposedly said. A disciple of Rikyū, Yamanoue Sōji (1544–1590), went on to explain, "In other words, it is good to place a famed Chinese utensil [*meibutsu*] in a roughhewn interior; the atmosphere then becomes all the more evocative."[27] It is in this ambiguous hinterland between China and Japan that Korean objects began to play a part in the newly conceptualized *wabi* tea.

Kōraimono: Introducing Korean Ceramics

While trade with Ming China flourished, Japanese merchants also exchanged goods with Joseon Korea. In the first half of the fifteenth century, fleets of about twenty to thirty ships left Japan for Korea annually. These fleets were smaller than those going to China, but they crossed the seas with greater frequency. Surviving records document a dazzling array of objects, sometimes with telling specificity, showing traders' knowledge of the market.[28]

Kōraimono, "Korean things," eventually displaced the Chinese pieces used in previous generations, if not in esteem then in sheer numbers. The term *Kōrai jawan*, "Korean tea bowl," first appears in 1537. Sporadic references follow with gaps of more than ten years until the 1560s, when Korean bowls begin to be mentioned with increasing frequency. By 1580 records show that people used Chinese and Korean bowls in equal numbers.[29] By 1588 *karamono* virtually dropped out of regular *chanoyu* practice, with Yamanoue Sōji declaring that "Chinese tea bowls have been abandoned."[30] The type of Korean bowl that epitomizes this development, first documented in 1578, is seen in an Ido tea bowl (see Ohki pl. 15); the foot (pl. 17) is shown here to give readers a complete view of the bowl, as it is appreciated by tea practitioners.[31]

Scholars have traditionally believed that Ido bowls, as well as other Korean wares then favored by the Japanese, such as Buncheong-ware tea bowls (see Ohki pl. 27), came from kilns operated by commoners for their own everyday use. One glance distinguishes them from the refined celadon and inlaid ceramics fired for the royal court. Nishida Hiroko contests their plebian origins, however, noting the lack of excavated examples in Korea for what was supposedly so common.[32] Nishida does not draw any conclusions, but such questions underlie the mystery of how these bowls came to be so highly valued in Japan.

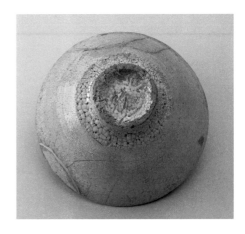

Plate 17.
Foot of tea bowl shown in Ohki pl. 15, Korean, 16th century. Ido ware; stoneware with crackled glaze and a fragment of a Kohiki bowl with gold lacquer repairs, 3 1/16 × 6 3/16 in. (7.8 × 15.7 cm). Promised gift to the Yale University Art Gallery of Peggy and Richard M. Danziger, LL.B. 1963. Cat. 27

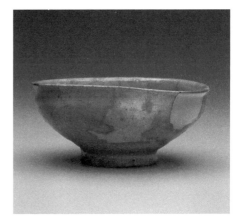

Plate 18.
Foot of Kohiki- or Muji Hakeme–type tea bowl shown in Ohki pl. 16, Korean, second half 16th century. Stoneware with white slip and transparent glaze with gold lacquer repair, 2 15/16 × 6 5/16 in. (7.5 × 16 cm). Promised gift to the Yale University Art Gallery of Peggy and Richard M. Danziger, LL.B. 1963. Cat. 55

Plate 19.
Incense Container (Kōgō), originally a Nailhead Cover from Jurakudai Palace, Japanese, ca. 1587. Wood with gold lacquer, 13/16 × 3¼ × 3³/16 in. (2.06 × 8.3 × 8.1 cm). Collection of Peggy and Richard M. Danziger, LL.B. 1963. Cat. 29

The idea that peasants originally made and used these bowls certainly suits the conceptualization of *wabi* tea. As we have seen, the drinking of tea had moved from the *shoin* to the *sōan*, "a mountain dwelling in the midst of a city" as it was described by the missionary João Rodrigues (1558–1633).[33] Shukō and his merchant, warrior, and monk disciples all lived in the city. They conceived of tea as an escape from the vulgarities and stresses of urban life punctuated by warfare. Using unpretentious utensils also served as an "antidote to the engulfing richness of the new consumer society."[34]

For the uninitiated, the beauty of an Ido bowl lay beyond comprehension, since it contradicted earlier ideals in ceramics. Whereas the Chinese bowls featured a lustrous glaze, the Ido bowls look unassuming with a matte, earthy finish. Spur marks left inside the bowls when potters fired them in stacks became a point of appraisal. Connoisseurs also esteemed the irregular, crackled glaze around their foot, calling it "plum blossom bark," a poetic reference to sharkskin, which was used on sword handles. The shape of the foot, too, commanded attention. Like the present example, most Ido bowls have a horizontal ridge around the middle of the foot that practitioners compared to a bamboo node. This specialized vocabulary played with Ido ware's characteristics, expressing admiration for what would have been considered flaws in earlier times.

The Kohiki tea bowl (pl. 18, and see Ohki pl. 16) is another Korean example from this period. It shows repairs of another sort than those found on the Ido bowl. As is visible on the right side of plate 18, close to the vessel's rim, gold lacquer has been used to fill a void. A spout used to be there, and a tea aficionado converted what was once a pourer into a tea bowl. The lack of excavated examples in Korea of this type of converted bowl indicates that the modification was made in Japan by the hand of a *chanoyu* master.[35] The valorization of the mundane is at work here, magically turning this everyday dish into a special utensil for *wabi* tea. The heavy stains from use, like many other "flaws," beckon appreciation for the bowl's history and prior lives.

In borrowing an item made originally for another purpose, one detects tea's creative connections with poetry, with tea masters playfully evoking associations and making "puns." Yet these objects also reflect another side of *wabi* tea, hardly mentioned in conventional views of *wabi* today. Practitioners constantly sought to expand their repertory of utensils, looking for ways to impress with their discrimination, creativity, and wealth. As Mary Elizabeth Berry observes, *wabi* seems in retrospect "less a consistent aesthetic than an unending search for variety and surprise," and *wabi* tea was "an art of invention and reinvention."[36] In bringing in an old kitchen pourer as a tea bowl, a practitioner displayed his originality, his complete mastery of the tea aesthetic to do as he pleased. In this spirit of innovation and eclecticism, a new genre of domestic wares also made its debut in the late sixteenth century.

Wamono: Japanese Wares in Tea

Wamono, "Japanese things," had already entered tea practice in Shukō's time, but a new domestic kind of earthenware produced especially for tea emerged during the late 1580s: Raku ware. It is first documented in a record of a tea gathering in 1580

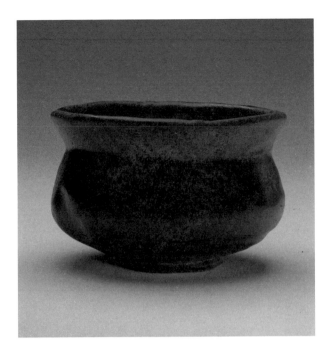

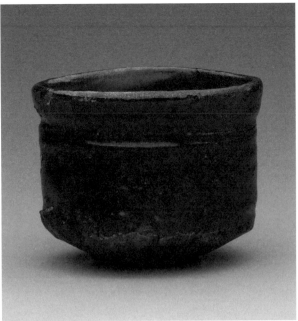

hosted by a certain Sōeki.[37] Sōeki was none other than the towering master of *wabi* tea, Sen no Rikyū. The next mention comes in 1586, when Matsuya Hisamasa noted at a party "a tea bowl in Sōeki's shape."[38] "*Sōeki-gata chawan*," or "*imayaki chawan*" (tea bowls in the new fashion), were used by tea practitioners in the late sixteenth century to refer to these bowls Rikyū espoused.

As this nomenclature suggests, Rikyū's hand in the shaping of these Raku bowls was vital to their introduction into *chanoyu*. Scholars have traditionally accepted that Rikyū guided the roof-tile maker Chōjirō in the crafting of Raku ware. The putative forefather of the Raku family of potters in Kyoto, Chōjirō descended from continental roof-tile makers who had immigrated to Japan. It is imagined that Rikyū encountered Chōjirō when the tile maker was working at the Jurakudai Palace of Toyotomi Hideyoshi (1537–1598).[39] An incense container (pl. 19) included here was made from a nailhead cover from this palace, which was dismantled in 1595. The Raku name, adopted a generation or two after Chōjirō, is thought to come from the family's ties to that area, where clay similar to that used in their bowls could be found. With Rikyū's perspicacious assessment of Chōjirō's skill, a fortuitous partnership emerged that gave birth to the Raku tea bowl, like the Black Raku tea bowl named *Kaedegure* (Twilight by the Maples; pl. 20, and see Ohki pl. 5).

Recent scholarship has, however, cast doubt on the identity of Chōjirō and his relationship to Rikyū.[40] Many now believe that Chōjirō's oeuvre, which encompasses several different styles, is actually a product of a workshop, perhaps led by Chōjirō. Indeed, *Kaedegure* exhibits a very unusual form, called *sakin bukuro*, the term for a pouch used to hold gold dust. Recent archaeological digs suggest, furthermore, that Raku ware was more widespread than previously thought. Some people now argue that "Raku" as a term to describe this ware is too restrictive since it suggests a family monopoly, and that it should be replaced by a more generic term to account for findings around Kyoto.[41]

The technological connection between Black Raku bowls and the Black Seto (Setoguro) bowls of the Mino kilns in present-day Gifu Prefecture has been made

Plate 20.
Attributed to Raku Chōjirō (Japanese, 1516–1592), foot of tea bowl named *Kaedegure* shown in Ohki pl. 5, late 16th century. Black Raku ware; earthenware with black glaze, 3⁹⁄₁₆ × 4¾ in. (9 × 12.1 cm). Promised gift to the Yale University Art Gallery of Peggy and Richard M. Danziger, ʟʟ.ʙ. 1963. Cat. 30

Plate 21.
Tsujimura Shirō (Japanese, born 1947), foot of tea bowl shown in Ohki pl. 18, ca. 2003. Mino-style ware, *hikidashiguro* type; stoneware with black glaze, 3⁹⁄₁₆ × 4⅞ in. (9.1 × 12.4 cm). Collection of Peggy and Richard M. Danziger, ʟʟ.ʙ. 1963. Cat. 85

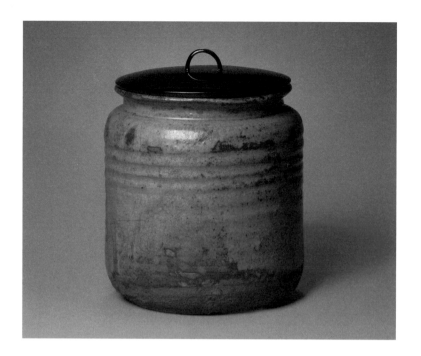

for some time.[42] Rikyū espoused black bowls, saying they conveyed the solemnity of old things.[43] Yet Raku bowls could not be produced in black initially, but rather were in red. It was assumed that the Kyoto potters in the Raku tradition borrowed from the Mino kilns the innovative *hikidashi* technique (mainly used for tea bowls), in which the potter suddenly withdraws the piece from the kiln at peak temperature to produce the black. This technique is thought to have resulted from attempts by the Mino potters to reproduce continental *tenmoku* bowls. Tsujimura Shirō's tea bowl included here (pl. 21, and see Ohki pl. 18) is a contemporary but faithful interpretation of the *hikidashiguro* style, with its low foot, hardly visible under the heavy, cylindrical form. In the past decade, however, archaeological excavations particularly around Osaka Castle have pushed forward the dating of many Seto and Mino kiln wares to after 1597, implying that Chōjirō himself may have invented the *hikidashi* technique to produce black tea bowls.[44] Yet an early Yellow Seto bowl once in the possession of Rikyū anticipates the silhouette of Chōjirō bowls. Akanuma Taka believes, moreover, that Mino potters were also making black Seto bowls with rounded bottoms (similar to Chōjirō's bowls) prior to the cylindrical Black Seto.[45] In any case, these parallels suggest a vibrant circulation of utensils, forms, and techniques between the Mino region and the capital.

Indeed, the Mino kilns represent, in Richard L. Wilson's words, "the locomotives of production" for the design and patronage from the capital.[46] The other major production was in southern Kyushu around Karatsu, an area of Japan closest to Korea, where transplanted Korean potters produced the *madara-garatsu* fresh-water jar (see Ohki pl. 23). Up north in the fifteenth century, the Mino kilns also began in the fifteenth century attempts to reproduce the esteemed continental wares. Yellow Seto is the earliest style among the Mino wares and may represent a failed attempt to re-create celadons. However, as tastes began to change, partly because of the unavailability of

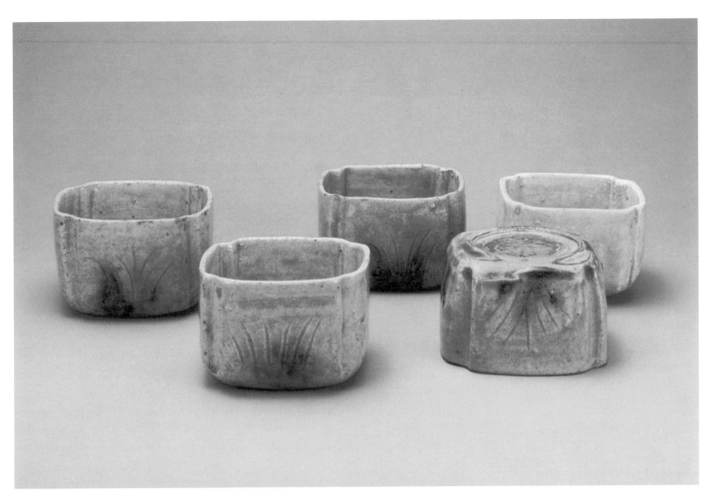

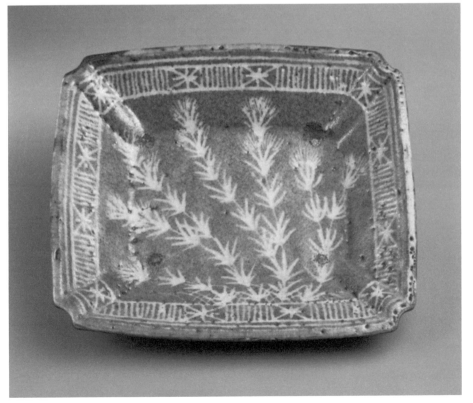

Plate 23.
Set of Dishes (*Mukōzuke*), Japanese, ca. 1600. Mino ware, Yellow Seto type; stoneware with yellow glaze, each 2⅜ × 3⁵⁄₁₆ in. (6 × 8.4 cm). Collection of Peggy and Richard M. Danziger, LL.B. 1963. Cat. 66

Plate 24.
Rectangular Plate, Japanese, late 16th–early 17th century. Mino ware, Gray Shino type; stoneware with slip and glaze and incised design, 8¹³⁄₁₆ × 7¹¹⁄₁₆ in. (22.4 × 19.6 cm). Collection of Peggy and Richard M. Danziger, LL.B. 1963. Cat. 67

older, imported treasures, the "irregular" pieces gained appreciation in their own right. The Yellow Seto fresh-water jar (pl. 22) probably predates the set of five Yellow Seto dishes (pl. 23) judging from its somber tinge, which echoes early Seto ware. The painted green accents (*tanpan*, or *tanban*) on the latter—*mukōzuke*, dishes used for the meal preceding the thick tea—were probably a later development when potters had abandoned attempts at recreating celadon, and worked with more secure knowledge about the glazes and the firing process.

Shino ware emerged after the Yellow and Black Seto according to current archaeological evidence. The original intent behind it may have been to produce white ceramics with underglaze painting, but the inefficient, moist kilns produced a "flawed" crawl of the glaze, sometimes described as "citron peel" (*yuzuhada*), a texture characteristic of Shino ware. An example of a Shino tea bowl is the one named *Onigawara* (Demon Tile; see Ohki pls. 28–29). A rectangular plate (pl. 24) in a gray variation of the standard white is a superb example of the Gray, or *nezumi* (mouse-colored), Shino type. After coating the clay body with a white slip, the potter applied an iron-rich glaze, then carved out the botanical design in the center and around the rim. The whole piece was finally dipped in a feldspathic glaze, the traditional white glaze of Shino ware. The iron slip usually turns gray, as in this example, but depending on firing conditions it could occasionally turn a brilliant red. Since the clay functioned rather like a canvas, this type of Shino decoration is usually found on plates, where the potter has room to carve the designs, commonly vines and foliage.

While ceramics dominate any discussion of *wamono*, other domestic pieces were being incorporated into *wabi* tea, and they followed a similar pattern of reappraisal and transformation. In lacquer, for instance, the emergence of the *wabi* aesthetic led connoisseurs to prize the worn look of Negoro ware. Negoro lacquer takes its name from Negoroji, a powerful Buddhist temple founded in 1140 in what is now Wakayama Prefecture. Monks presumably began making lacquer dishes for temple use shortly after its founding. Negoro lacquer consisted of multiple layers of black lacquer under a topcoat of red. By the Muromachi period, the red layer had worn off in patches on many pieces and created a worn, mottled look. With the emergence of the *wabi* aesthetic, this aged look, the Buddhist associations, and the simple restrained elegance of the pieces made Negoro ware highly valued in tea practice. By this time, "Negoro" came to be a generic term for such lacquer, which was purposely produced with this antique appearance, and in many regions. The nobleman's meal table (pl. 25), which would be reserved for honored guests, is an example of the *wabi* beauty of the Negoro-lacquer trays, tea caddies, and meal utensils used in *chanoyu*.

Negoro ware was not the only type of lacquer, however, just as *wabi* was not the sole aesthetic during the late sixteenth century. Indeed, Rikyū himself owned Chinese ceramics, which continued to be part of tea practitioners' collections. The *wabi* aesthetic merely changed the emphasis away from the luxurious Chinese wares as well as the combinations in which people used these objects. The antithesis of the Negoro style in lacquer is Kōdaiji *maki-e* (sprinkled picture), which is named after the mortuary convent of Hideyoshi's principal wife, where superlative examples of this lacquerware can be found. There, lacquer with fine illustrations in polished gold and other precious materials lavishly decorates the Toyotomi

shrine. A mirror box used as an incense container in the tea context (pl. 26) is a miniature example of Kōdaiji *maki-e*. The Toyotomi crest of the paulownia tree decorates the surface.

Righting a World Turned Upside Down

Besides its lacquer, Negoroji was also famous for another product: its harquebus. Firearms were brought to Japan in 1543 by the Portuguese trader Fernão Mendes Pinto, who had landed in Tanegashima at the southern tip of Kyushu. Expert Japanese swordsmiths managed to reproduce the Portuguese model by 1545. Negoroji was home to militant monks with a tradition of training in the martial arts. They soon began producing copies of the Portuguese harquebus, and sold them to meet the high demand by warlords such as Oda Nobunaga (1534–1582), who saw their potential to revolutionize warfare. While the impact of the Portuguese may not have manifested itself directly in tea practice, a connection between trade in firearms and tea patronage cannot be denied. Besides Negoroji and Tanegashima, another center for the sale of these new weapons was the port city of Sakai, the original home of Rikyū. Much wealth was to be made from imports, and it fueled the rise of the merchant class in Sakai, who used this income to procure new tea utensils and to pursue the way of tea, which had expanded beyond the ruling class.

Firearms were thus yet another symbol of the turbulence of the late Muromachi period. We have already seen how, at least in the arts, the Ashikaga shoguns and the military clan lords such as Sasaki Dōyo associated with artists and performers who were traditionally on the margins of society. A colorful term to describe this phenomenon arose: *gekokujō*, "the lower commanding the upper," which metaphorically could be rendered, "the world turned upside down."[47] By not requiring much training, the Portuguese harquebus exacerbated this trend, for it allowed upstart smaller daimyo such as Nobunaga to annihilate the superb cavalry of the Takeda clan, descended from a more distinguished lineage. In the realm of *chanoyu*, rustic, "flawed" Japanese wares from the Mino and other old kilns achieved prominence, though Chinese wares never lost their appeal or respect. Merchants with plebian backgrounds, such as Rikyū, became highly influential tea masters who taught the ruling class, including the ascendant Nobunaga and Hideyoshi, both of whom used tea as cultural capital to buttress their weak traditional claims to authority.

Indeed, Hideyoshi himself was a prime example of the social whirlwind of the sixteenth century. Coming from a peasant background, he originally did not even have a family name, and he started his meteoric rise to power as a lowly foot soldier in Nobunaga's service. Only in this period could a figure like Hideyoshi emerge to gain control over the entire country. Perhaps precisely because of his background, Hideyoshi worked assiduously to restore the social hierarchy when he reached power, confiscating weapons from farmers, freezing social and geographical mobility, and destroying the monastic complex of Negoroji, which had threatened his authority in its militant independence and production of firearms.[48]

When Hideyoshi ordered Rikyū to commit suicide, his actions to arrest social instability arguably extended into *chanoyu*. While there are many theories of varying persuasiveness trying to explain the reasons behind Hideyoshi's order, the most

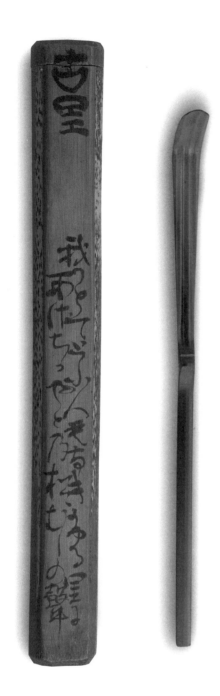

convincing comes from Mary Elizabeth Berry, who relies on one telling quotation from a contemporary observer: "In [tea] objects he liked, [Rikyū] declared good points bad and bought them for mean prices. In vessels he disdained, [Rikyū] declared bad points good and bought them at high prices. He called new old and old new. No he made yes, false he made genuine."[49] Such observations echo those of Yamanoue Sōji, who, despite being a disciple of the master, found a similar iconoclasm in judgment: "[Rikyū] made mountains into valleys, west into east, and broke the rules of *chanoyu*. But if the ordinary person were simply to imitate him, there would be no *chanoyu*."[50] From such statements, Berry argues that "Rikyū stood accused of wreaking havoc, exposing the volatility of aesthetic and economic value, of judgment and cultural authority."[51] Hideyoshi may have had personal grudges against Rikyū. He may have even been mentally unstable at this age.[52] Ultimately, though, "for Hideyoshi, a man resolved to fix the moorings of a world at drift, the havoc of play registered and helped propel havoc everywhere. Rikyū was sacrificed to the goal of clear meanings and certain authority."[53] Should priceless tea utensils be one day deemed worthless by Rikyū, the system of rewards Hideyoshi and other military rulers relied upon in the face of dwindling land to redistribute would fall apart, and along with it, Hideyoshi's authority.

As we have seen, however, *chanoyu* thrived on breaking through limitations, whether in terms of objects, aesthetics, or social hierarchy. With Rikyū's passing, the age of vibrant circulation that had characterized much of Muromachi culture was gone. Indeed, Hideyoshi's attempts to freeze social mobility and to establish peace through his own authority were successful and became the foundation of stable rule for Tokugawa Ieyasu (1542–1616), a rival warlord who defeated the Toyotomi and established the Edo shogunate. *Chanoyu* of the Edo period (1615–1868) became the province of the ruling class, and in many ways lost the vitality of the earlier period. Instead of warfare, which ceased with the great peace of the Edo period, arguably the longest duration of national peace in world history, the samurai class pursued *chanoyu* among other cultural and learned activities. While Yamanoue Sōji was correct in pointing to the irreproducibility of Rikyū's art, tea had been always protean and changed in response to the historical context. It was no different in the Edo period. *Chanoyu* reflected the stability of the times and the rigid social system the Tokugawa imposed. Only then did reproducibility and a certain imitation enter into tea practice as an ideal, as practitioners vied to inherit and re-create the tea of Rikyū.

Tea of the Daimyo in the Edo Period

When Rikyū was banished to Sakai from Kyoto as a prelude to his ordered suicide, the master was seen off by two of his leading disciples, Furuta Oribe (1543–1615) and Hosokawa Sansai (1563–1645). Both came from distinguished warrior-class families. Oribe's taste tended to be exuberant; his namesake ware features now-modernistic-appearing, abstract designs inspired by textile patterns, and exaggerated, misshapen forms that hark back to *basara* flamboyance. His bamboo flower container (see Ohki pls. 4 and 31) shows Oribe's more orthodox side, emulating his master Rikyū's tastes. Oribe was suspected by the Tokugawa of having conspired with the Toyotomi during the Siege of Osaka in 1615, and he was ordered to com-

Plate 27.
Kobori Enshū (Japanese, 1579–1647), *Tea Scoop, named Furusato (Hometown)*, showing bamboo canister with inscription by Enshū, first half 17th century. Bent and carved bamboo, L. 7⅛ in. (18 cm). Collection of Peggy and Richard M. Danziger, LL.B. 1963. Cat. 70

mit suicide. It might be said that, like his teacher Rikyū, Oribe foresaw and could not accept the new ethos represented by the Tokugawa. Conversely, Sansai cut a more conservative figure.

One famous story relates how a fellow daimyo, Hotta Masamori (1608–1651), once asked Sansai to show him his famed utensils. Sansai agreed, but when his guest arrived, he found to his surprise only armor and weapons. When asked through a messenger why he had not shown the lord the desired tea utensils, Sansai replied, "I did not show them because, when you first came here, you simply asked me to show your master my treasured implements. When we speak of treasured implements in a warrior's house, the meaning can be nothing but weapons and armor. Therefore I did not exhibit my tea utensils at all."[54] This anecdote illustrates how the samurai class had lost their military orientation already by the first half of the seventeenth century, to assume that "treasured implements" could signify first a warrior's tea utensils. According to Sansai, a survivor of the bloody period of factional warfare, a samurai should never forget his original purpose.

Yet as peace continued, and as figures such as Sansai, too, passed away, tea unavoidably became a site for social distinction. Not on the battlefield, but in the tea room did daimyo practitioners subtly demarcate hierarchy in new configurations, creating additional, inferior spaces for attendants to the samurai, or locating the area of tea preparation in front of the alcove, so as to seat the lord in the place of honor while he made tea.[55] Utensils, too, came to reflect samurai taste for more refined pieces. Just as the Tokugawa shogunate propagated Chinese, Neo-Confucian ideology to confirm its vision of an ordered society, Chinese utensils regained favor. Indeed, the collection of the Ashikaga shoguns came to be designated as "pieces of great fame" (ōmeibutsu) signaling continued interest in acquiring those objects and their prestige accrued by their pedigree.

The tea bowl decorated with dragon medallions (see Ohki pl. 26) is a Chinese porcelain bowl with roundels painted in underglaze cobalt blue. This style of sometsuke ware was particularly esteemed by Kobori Enshū (1579–1647), a disciple of Oribe and an official of the Tokugawa shogunate. Enshū also ushered in a revival of classical poetry, epitomized in his calligraphy, which is visible on the canister housing his tea scoop called *Furusato* (Hometown; pl. 27). Tea scoops had been given names prior to Enshū, but he established a tradition of inscribing poetry to contextualize the name. Enshū's calligraphy imitated the style of Fujiwara Teika (1162–1241), one of the most celebrated Japanese poets of the early medieval age.

Hon'ami Kōetsu

The revival of classical poetry can also be seen in the work of Hon'ami Kōetsu (1558–1637), whose calligraphy, too, was highly esteemed. Kōetsu's collaborations with many artists and his artistic production in various art forms and media are reminiscent of the role of Sasaki Dōyo of two centuries before. Indeed, Kan'ei-era culture (1624–44), of which Kōetsu was a vital part, was the last flowering of the dynamic, cultural renaissance that had occurred during the sixteenth century. Kōetsu came from a family of sword polishers, an occupation that changed as Japan entered peacetime from an essential martial art to one of connoisseurship. His inherited skills put him into contact with many prominent daimyo of the time,

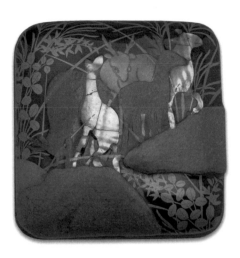

Plate 28.
Incense Container (Kōgō) with Kōrin-Style Design, Japanese, 18th century. Lacquer on wood with mother-of-pearl, gold, and pewter decoration, 1¾ × 3⅝ in. (4.5 × 9.2 cm). Collection of Peggy and Richard M. Danziger, LL.B. 1963. Cat. 76

allowing him to act as a coordinator between patrons and artists when society was becoming more hierarchical and the transgression of class boundaries was becoming almost impossible.

Kōetsu's artistic endeavors demonstrate a spirit of collaboration between artists in almost all of the cultural forms of their day. Kōetsu's calligraphic works often consisted of classical poetry brushed on luxuriously decorated paper with paintings by Tawaraya Sōtatsu, with whom Kōetsu had a fruitful relationship. Their designs were highly influential and were replicated in lacquer, as seen in the incense container with a design of Kōrin-style deer (pl. 28) from the eighteenth century. Kōetsu also copied libretti of Nō dramas in his graceful, legible hand, which were printed with woodblocks, and made ceramics—distinctive Raku bowls—which he asked the second-generation Raku master, Jōkei, to fire for him. This relationship is documented in several surviving letters between Kōetsu and Jōkei, among which is the *Letter to Raku Kichizaemon* (pl. 29), dating from about 1615 to 1635.[56] In this brief note, Kōetsu tells Kichizaemon (all Raku family potters use the artist name Kichizaemon, and after their deaths they are distinguished by their Buddhist names) that the tea bowls are ready for him to pick up, glaze, and fire at the Raku kiln.

The letter is assumed to have been written after 1615, when Tokugawa Ieyasu granted Kōetsu a plot of land in the northwest outskirts of Kyoto, an area known as Takagamine. There, Kōetsu formed what has been described as an artists' colony, though its religious association has been emphasized as well. His name suggests that the Hon'ami family had strong connections to the Lotus (Hokke) sect, which had many devotees in the artisan population (including the Raku house) and among the merchants, the latter because of the sect's rare valorization of making money. Kōetsu's network of religious, artistic, and military figures echoed the vanishing spirit of the late Muromachi age, when diverse classes of people, among them samurai, Buddhist monks, Shinto priests, poets, potters, and courtesans, created and freely inhabited a world of art.

Sen Sōtan and the Iemoto System

When Hideyoshi ordered Sen no Rikyū to commit suicide, a shadow was cast over the Sen family, and Rikyū's son, Sen Shōan (1546–1614), went into exile in Aizu Wakamatsu, in northern Japan. Perhaps suffering from some regrets over his actions, and owing to Tokugawa Ieyasu's intervention, Hideyoshi allowed Sen Shōan to return to Kyoto in 1594. Shōan's son and successor, Sen Sōtan (1578–1658)—having seen through his grandfather's life the unreliability and the dangers of political patronage—never entered the service of a daimyo. Yet he urged his sons to find employment with various samurai households, and they created three separate lineages, of which at least one, he hoped, would endure. These three lineages, the Omote Senke, the Ura Senke, and the Mushanokōji Senke, are the three main tea schools in Japan today.

During the Edo period, the role Kōetsu had filled in coordinating artists and patrons for various artistic endeavors was partly assumed by the hereditary heads (*iemoto*) of the tea schools. Being forefather to all three schools (in addition to Rikyū himself, who assumed a mythical stature), Sōtan defined the position for his

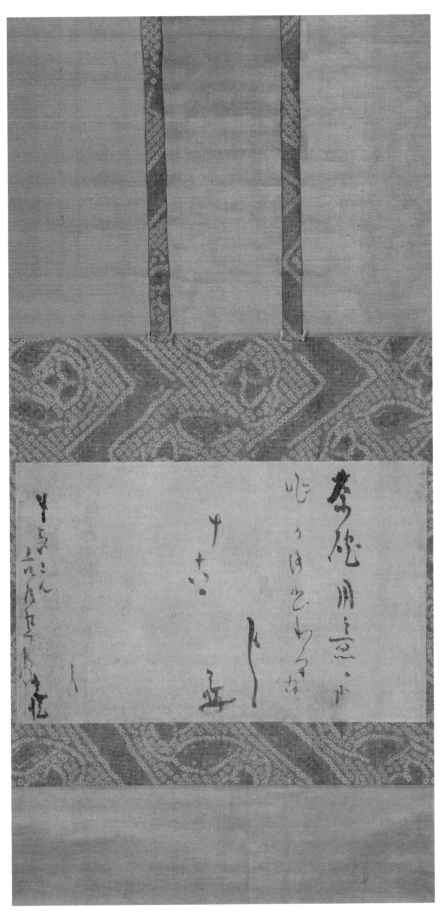

Plate 29.
Hon'ami Kōetsu (Japanese, 1558–1637), *Letter to Raku Kichizaemon*, ca. 1615–35. Hanging scroll; ink on paper, 10 13/16 × 17 11/16 in. (27.5 × 45 cm). Collection of Peggy and Richard M. Danziger, LL.B. 1963. Cat. 68

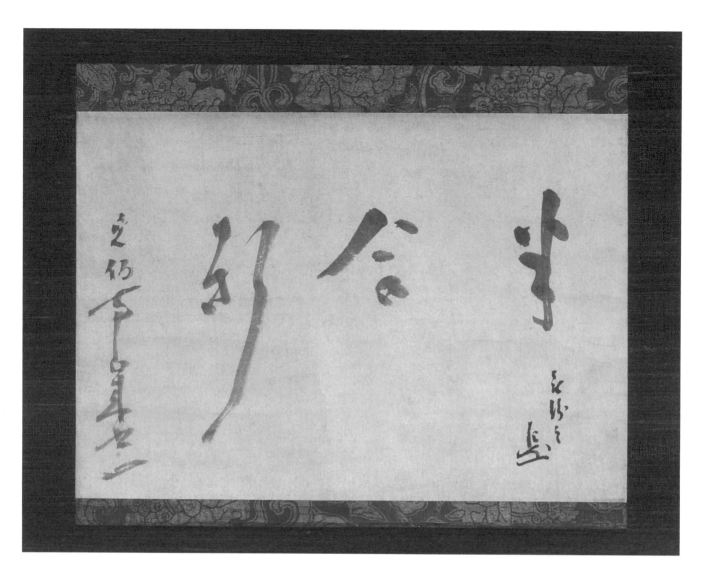

Plate 30.

Sen Sōtan (Japanese, 1578–1658), *"Hangōken"*
Calligraphy, 1646. Hanging scroll; ink on paper,
20 11/16 × 46 1/16 in. (52.5 × 117 cm). Collection of
Peggy and Richard M. Danziger, LL.B. 1963. Cat. 35

descendants. Among various tasks, Sōtan evaluated utensils and validated ones he deemed suitable for use in tea practice. For instance, the Old Bizen hanging flower container (see pl. 16 above) may have been converted for use in tea by Sōtan or a disciple. Sōtan then marked his approval with his cipher (*kaō*) in red lacquer on the container's back. Sōtan also coordinated the activities of various artisan families that produced tea utensils. In the eighteenth century, ten families would be systemized as the Ten Craft Houses (*jisshoku*) that worked under the patronage and direction of the three Sen *iemoto*. Among the Ten Craft Houses is the family of lacquer artisans descended from Hiki Ikkan (1578–1657), who was originally from China, then in the midst of turmoil during the emergence of the Qing dynasty (1644–1911). The hanging scroll of the calligraphed *Hangōken* (pl. 30, and see Ohki pl. 3) may be related to the name of the teahouse Hangoken (written with different characters) that Sōtan gave to Ikkan.[57] Sōtan was often asked to give tea names to his disciples, as well as names to teahouses. His calligraphy would then be transferred to wooden plaques that would be hung by the rooms. Perhaps Sōtan was recycling the idea; the name exhibits humility, stating that the master is only good enough for the "after-meal tea" (*hangocha*) and not the full, formal protocol. Since Sōtan signed the *Hangōken* scroll shown here with his age as seventy, it probably dates after Sōtan gave Ikkan the Hangoken name. At the bottom right, Ryōryōsai Sōsa (1775–1825), the ninth-generation successor to Sōtan in the Omote Senke, brushed his cipher authenticating the calligraphy, to which he added a few words of elation at encountering the piece.

Plate 31.
Tin-Glazed Sake Cup, Dutch, 17th–18th century. Stoneware with tin glaze and floral decoration in blue, green, and orange, 1¾ × 2⅜ in. (4.5 × 6 cm). Collection of Peggy and Richard M. Danziger, LL.B. 1963. Cat. 75

Encounter with the West

The establishment of the *iemoto* system was a great success in that it established the three Sen families and maintained their tradition of *chanoyu* to this day. Yet like that of the Tokugawa shogunate itself, which achieved peace for more than two centuries, this stability came at a certain price. Intent on preserving Rikyū's style of tea, the *iemoto* system was inherently conservative, and the schools' role as arbiters of tea taste inhibited the radical innovation that had been the hallmark of *wabi* tea when it emerged during the sixteenth century.

Yet *chanoyu* in the Edo period was not completely static. A harbinger of one direction tea would take in the nineteenth century grew out of the limited amount of trade with the Dutch allowed by the Tokugawa during a period of restricted international contacts. The Japanese were initially enthusiastic importers of Portuguese goods, as shown by the Japanese adoption of firearms. However, Hideyoshi grew increasingly suspicious of Jesuit missionaries, and issued his first anti-Christian edicts in 1587. Intent on securing his sole authority, he ordered the crucifixion of twenty-six Japanese and Spanish Franciscan Christians in 1597. When the Dutch arrived in Japan, Tokugawa Ieyasu saw a suitable, nonproselytizing alternative to the Catholic traders, and eventually he expelled the remaining Portuguese. Although the shogunate confined the Dutch to a small, manmade island in the distant port of Nagasaki, their influence could be detected in the Dutch wares that entered tea practice. The Dutch tin-glazed sake cup shown here (pl. 31) may have been adapted from other uses. The Dutch small brazier for a tobacco tray (pl. 32) may also have been originally made for another purpose, though it seems more likely that it was commissioned by Japanese patrons.

Plate 32.
Small Charger used as a Brazier for a Tobacco Tray, Dutch, 18th century. Delft ware; stoneware with overglaze blue decoration on white slip and clear glaze, 4⁵⁄₁₆ × 3¹³⁄₁₆ in. (11 × 9.7 cm). Collection of Peggy and Richard M. Danziger, LL.B. 1963. Cat. 38

Plate 33.

Guan-Ware Incense Container with a Raku Lid and an Added Dragon Handle, showing box with inscription by Ryōnyū and his seal, Chinese, Japanese, American; 13th century, late 18th century, 20th century. Container: Guan ware with gold repair; lid: Red Raku ware by Raku Kichizaemon IX (Ryōnyū; 1756–1834), earthenware with glaze; handle: pewter, overall 1⅞ × 2⁵⁄₁₆ × 2⅜ in. (4.8 × 5.8 × 6 cm) (with lid). Collection of Peggy and Richard M. Danziger, LL.B. 1963. Cat. 46

When the Tokugawa regime collapsed after the forced opening of Japan by the United States in a series of events beginning with Commodore Perry's first expedition to Japan in 1853, *chanoyu* also faced the biggest challenge to its survival in having to accommodate a radically altered world order. With the importation of Western ideas, technology, and art forms, public interest shifted to these novel areas. Yet, as Sadako Ohki's essay in this volume makes clear, it was the redrawing of boundaries between Japan and the world beyond, and the introduction of tea to new audiences around the globe, that energized *chanoyu* and gave the tradition renewed vitality.

The incense container made with Guan ware (pl. 33) embodies the creativity *chanoyu* fostered at the crossroads of various cultures. The oldest component of the work is a thirteenth-century, Southern Song, Guan-ware square container. The subdued coloration and the crackled glaze no doubt appealed to Japanese taste, for Raku Ryōnyū (ninth-generation head of the Raku house; 1756–1834) added a lid of Red Raku ware in the late eighteenth century. Ryōnyū's description of this composite work for which he also inscribed and stamped the lid shows that he viewed it as a tea caddy (*cha-ire*). While it may certainly serve this function, it is too small to be practical, a sentiment perhaps shared by a more recent owner, who had an American artist attach a pewter, dragon-shaped handle to the lid, effectively turning the work into an incense container. The multiple layers of additions and adaptations that span centuries and continents are emblematic of *chanoyu* and its foundations. Indeed, as we have seen, *chanoyu* epitomizes a perennial characteristic of Japanese culture: to thrive on the incorporation of foreign goods and concepts, breaking down boundaries between people, ideas, and things.

NOTES

I would like to thank my many teachers and friends who have shared their knowledge of *chanoyu* with me.

1 *Nanpōroku*, trans. Dennis Hirota, in *Wind in the Pines: Classic Writings of the Way of Tea as a Buddhist Path* (Fremont, Calif.: Asian Humanities Press, 1995), 236.

2 I thank Gregory Kinsey for the estimate of tea aficionados based on membership numbers of the various tea schools at the time of the 400th memorial services for Sen no Rikyū in 1990.

3 *Nihon kōki*, in *Shintei zōho kokushi taikei*, ed. Kuroita Katsumi (Tokyo: Yoshikawa Kōbunkan, 2000), entry for 4th month, 22nd day, Kōnin 6 (815).

4 This episode is documented in *Azuma kagami*, 2nd month, 4th day, Kenpō 2 (1214). Passage quoted in Sen Sōshitsu, *The Japanese Way of Tea: From Its Origins in China to Sen no Rikyū* (Honolulu: University of Hawaii Press, 1998), 59.

5 For details about this type of ceremony, see Paul Varley and George Elison, "The Culture of Tea from Its Origins to Sen no Rikyū," in *Warlords, Artists, and Commoners*, ed. George Elison and Bardwell Smith (Honolulu: University of Hawaii Press, 1981), 195–96. For some photographs, see Murai Yasuhiko, *Sen no Rikyū: Sono shōgai to chanoyu no imi* (Tokyo: Nihon Hōsō Shuppan Kyōkai, 1976), 15.

6 Mujū Ichien, *Shasekishū*, in *Nihon koten bungaku taikei*, ed. Watanabe Tsunaya, vol. 85 (Tokyo: Iwanami Shoten, 1966), 500–501.

7 For an explanation of the tea contest and what we know of its rules and protocols, see Sen, *The Japanese Way of Tea*, 98–109.

8 Ibid., 115.

9 *Taiheiki*, Book 39, in *Shinpen Nihon koten bungaku zenshū*, vol. 57 (Tokyo: Shōgakukan, 1998), 392–95. For a retelling of this episode, see Matsuoka Shinpei, *Utage no shintai: Basara kara Zeami e* (Tokyo: Iwanami Shoten, 2004), 44–47.

10 For a discussion of the *hana no moto renga*, see Matsuoka, *Utage no shintai*, 51–63.

11 Matsuoka Shinpei, "Muromachi no geinō," in *Iwanami kōza Nihon tsūshi*, vol. 9 (Tokyo: Iwanami Shoten, 1994), 259–60. For more on the connections of *renga* with *wabi* and *chanoyu*, see Hirota, *Wind in the Pines*, 37–87.

12 Matsuoka, *Utage no shintai*, 228–29.

13 For more information on the "people of the riverbanks," see Pierre Souyri, *The World Turned Upside Down: Medieval Japanese Society* (New York: Columbia University Press, 2001), 176–78.

14 Ibid., 176.

15 Ibid., 109.

16 In Wm. Theodore de Bary, Donald Keene, George Tanabe, and Paul Varley, comps., *Sources of the Japanese Tradition*, vol. 1 (New York: Columbia University Press, 2001), 419. I have inserted "*basara*" where it was omitted in the translation.

17 *Taiheiki*, Book 36, in *Shinpen Nihon koten bungaku zenshū*, 236–37; and Matsuoka Shinpei, "Muromachi no geinō," 267–68. A brief excerpt of the account from *Taiheiki* is translated in Sen, *Japanese Way of Tea*, 92.

18 Jennifer Anderson, *An Introduction to Japanese Tea Ritual* (Albany: State University of New York Press, 1991), 27.

19 Akanuma Taka, ed., *Chatō no bi: Chatō no sōsei—karamono kara wamono e* (Kyoto: Tankōsha, 2004), 1:5.

20 Hayashiya Tatsusaburō, ed., *Chadō daijiten* (Tokyo: Kadokawa Shoten, 2002), 636–37.

21 For calligraphic works that commemorate Ikkyū's cherished relationships with Mori, a blind singer, and a sparrow (to which Ikkyū gave a posthumous Buddhist name, Sonrin), see Helmut Brinker and Hiroshi Kanazawa, *Zen: Masters of Meditation in Images and Writings* (Zurich: Artibus Asiae Publishers, 1996), 189, 260–61.

22 The identification of Shukō as the first to use Chan scrolls (*bokuseki*) in the tea room is made by Yamanoue Sōji in his diary. For a translation of the relevant passage, see Gregory Levine, *Daitokuji: The Visual Cultures of a Zen Monastery* (Seattle: University of Washington Press, 2005), 154.

23 Quoted in Hirota, *Wind in the Pines*, 198. For further discussion, see Louise Cort, *Shigaraki: Potters' Valley* (Tokyo: Kōdansha International, 1979), 111–12.

24 Matsuoka, "Muromachi no geinō," 289–90.

25 Ibid., 290.

26 Cort, *Shigaraki*, 110.

27 Quoted in Hirota, *Wind in the Pines*, 70.

28 See Nishida Hiroko, ed., *Kanzō chawan hyakusen* (Tokyo: Nezu Bijutsukan, 1994), 112–13. Nishida's comments are based on Tanaka Takeo, *Chūsei taigai kankei shi* (Tokyo: Tokyo Daigaku Shuppankai, 1975).

29 Akanuma, *Chatō no bi*, 1:130–31.

30 Quoted in Hayashiya Seizō, "Teabowls," *Chanoyu Quarterly* 55 (1988): 35.

31 This type of Korean bowl was documented in *Tennōjiya kaiki* (10th month, 25th day) as appearing in a party hosted by Yabunouchi Sōwa; see Akanuma, *Chatō no bi*, 1:131.

32 Nishida, *Kanzō chawan hyakusen*, English synopsis, vi.

33 Michael Cooper, ed., *João Rodrigues's Account of Sixteenth-Century Japan* (London: Hakluyt Society, 2001), 291.

34 Cort, *Shigaraki*, 129.

35 Tokugawa Art Museum and Gotoh Museum, *Chanoyu meiwan: Aratanaru Edo no biishiki* (Nagoya: Tokugawa Art Museum; Tokyo: Gotoh Museum, 2005), 162.

36 Mary Elizabeth Berry, *The Culture of Civil War in Kyoto* (Berkeley: University of California Press, 1994), 262.

37 "*Hata no sori taru chawan*" ("a tea bowl of which the sides flare out") is found in *Tennōjiya kaiki*, 12th month, 9th day, Tenshō 8 (1580). Quoted in Akanuma, *Chatō no bi*, 1:82–83.

38 The term appears in Matsuya Kaiki, 10th month, 13th day, Tenshō 14 (1586). Quoted in Akanuma, *Chatō no bi*, 1:83.

39 A chronicle of the warlord Oda Nobunaga's rule documents foreign tile makers working at the Nijō palace, Kyoto, in 1569. Furthermore, a dish in the three-color style (*sancai*) attributed to Chōjirō links him to similar ceramics produced in Zhangzhou, Fujian, China. See Morgan Pitelka, *Handmade Culture: Raku Potters, Patrons, and Tea Practitioners in Japan* (Honolulu: University of Hawaii Press, 2005), 37.

40 In English, the most notable study arguing this reassessment is Pitelka's *Handmade Culture*.

41 Takeuchi Jun'ichi and Watanabe Setsuo, *Sen Rikyū to yakimono kakumei: Momoyama bunka no dai-bakuhatsu* (Tokyo: Kawade Shobō Shinsha, 1998), 138.

42 For technical information about Raku bowls, and comparison with Black Seto bowls, see Richard L. Wilson, *Inside Japanese Ceramics* (New York: Weatherhill, 1995), 166–68.

43 Kamiya Sōtan recorded Rikyū as saying "black imparts a feeling of age" (*Sōtan nikki*); quoted in Akanuma, *Chatō no bi*, 1:83. Rikyū favored black bowls despite Hideyoshi's dislike of them, Sōtan also wrote in 1590.

44 Akanuma, *Chatō no bi*, 1:87, 2:120–21.

45 Early Mino wares seem to have been disposable to a certain extent, so not many examples survive. A few examples of early black Seto bowls that might have inspired Chōjirō and Rikyū are published in Akanuma, *Chatō no bi*, 2:14, 121. For an illustration of Rikyū's Yellow Seto bowl, see ibid., 1:109.

46 Wilson, *Inside Japanese Ceramics*, 29.

47 Souyri, *World Turned Upside Down*, 4.

48 Mary Elizabeth Berry, *Hideyoshi* (Cambridge, Mass.: Harvard University Press, 1982), 85–86, 102–11.

49 Berry, *Culture of Civil War*, 242.

50 Yamanoue Sōji, *Yamanoue Sōji ki, Chadō koten zenshū*, vol. 6 (Kyoto: Tankōsha, 1967), 102; translated in Sen, *Japanese Way of Tea*, vii.

51 Berry, *Culture of Civil War*, 242.

52 For a summary of some of the theories and the events surrounding Rikyū's suicide, see Levine, *Daitokuji*, 111–12.

53 Berry, *Culture of Civil War*, 243.

54 Chikamatsu Shigenori, *Stories from a Tearoom Window*, trans. Kozaburo Mori (Rutland, Vt.: Tuttle, 1982), 56.

55 Rooms designed by Oribe (for example, En'an in Kyoto) have this attendants' area (*shōbanseki*),

while the Sekishū school (a daimyo-style school of *chanoyu*) place the tea preparation area (*temaeza*) in front of the alcove (*teishu toko*). Hayashiya, *Chadō daijiten*, 176, 593–94.

56 This letter has been discussed by Louise Cort in *Crosscurrents: Masterpieces of East Asian Art from New York Private Collections*, ed. Amy Poster (New York: Japan Society, 1999), 126–29. Several other letters from Kōetsu to Jōkei are published and discussed in Felice Fischer, *The Arts of Hon'ami Kōetsu: Japanese Renaissance Master* (Philadelphia: Philadelphia Museum of Art, 2000), 142, 213, cats. 100–101.

57 For a small illustration of the calligraphy given to Ikkan, see Hiki Ikkan (XVI; sixteenth generation), "Wabicha no kokoro: Ikkan-bari no sekai," *Tankō* 58, no. 6 (2004): 23. The Danziger collection *Hangōken* has been published in Yoshiaki Shimizu and John Rosenfield, *Masters of Japanese Calligraphy, 8th–19th Century* (New York: Asia Society Galleries, 1984), 198–99.

Section I.
Before Wabi
Evoking the
Basara Aesthetic

わび以前
婆沙羅趣向

1a–b.
Pair of Six-Panel Screens: Cherry and Maple
Japanese, 17th century
Pair of six-panel screens; ink, mineral color, and gold and silver pigment on paper,
each 62 in. × 9 ft. 2 ½ in. (157.5 × 280.7 cm)
桜楓六曲一双屏風　紙本着色　江戸時代
Collection of Peggy and Richard M. Danziger, LL.B. 1963

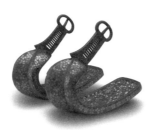

2.
Shigenaga (Japanese, 17th–18th century)
Pair of Stirrups, 17th–18th century
Cast iron, metal alloys, and mother-of-pearl, 9 ⅝ × 5 ³⁄₁₆ × 11 ⅝ in.
(24.5 × 13.2 × 29.5 cm)
重長　鐙　阿古屋貝象嵌鉄しろめ　江戸時代
Collection of Peggy and Richard M. Danziger, LL.B. 1963

3.
Nō Robe, Atsuita Style
Japanese, late 18th century
Compound twill, brocaded silk, L. in back 57 ¾ in. (146.7 cm),
w. overall 55 ⅛ in. (140 cm)
Historical Note: Acquired by exchange for 15 priest robes from the
Keane collection
能装束　厚板雷紋綾織錦　江戸時代
Yale University Art Gallery, The Hobart and Edward Small Moore
Memorial Collection, Gift of Mrs. William H. Moore
1955.39.1

4.
Tea Picnic Basket Set (Chakago)
Japanese, 18th–20th century
Basket: Ikeda Hyōa (Japanese, died 1934), 19th–20th century; *Black Oribe–Type
Tea Bowl*: 18th–19th century; *Lacquer Tea Caddy (Natsume); Tea Whisk with Woven
Bamboo; Tea Whisk Holder, Ivory Tea Scoop; Tea-Cloth Holder*
Woven bamboo; stoneware; lacquered wood; bamboo and woven bamboo; ivory;
and porcelain with underglaze blue decoration, basket 4 ¾ × 6 ⅜ in.
(12.1 × 16.2 cm)
Historical Note: Provenance unknown, although Hyōa received many
commissions from Masuda Don'ō (Takashi; 1848–1938)
池田瓢阿　他　茶籠　倣黒織部茶碗、真塗棗、茶筅、茶筅筒、
象牙茶杓、茶巾筒　江戸～明治時代
Collection of Peggy and Richard M. Danziger, LL.B. 1963

5.

Orange-Laced Dōmaru Suit of Armor
Japanese, late 18th–mid-19th century (in the style of 13th–14th century)
Lacquered iron with silk lacing, 66 × 30 × 29 in. (167.6 × 76.2 × 73.7 cm)
Historical Note: Box inscription states the suit belonged to the Honda family of
Mikawa Province (present-day Aichi Prefecture) when it was conserved in 1855
緋縅胴丸　漆鉄絹　江戸時代
Yale University Art Gallery, Purchased with funds from the Japan Foundation
Endowment of the Council on East Asian Studies
2008.84.1a–r

On view in the Ruth and Bruce Dayton Gallery of Asian Art, on the second floor
of the Yale University Art Gallery.

6.

Covered Cosmetic Box
Chinese, 8th–9th century
Stoneware, quatrefoil molded design, and remnants of green glaze,
2 ¾ × 2 ¼ in. (7 × 5.7 cm)
綠釉花弁紋盒　中国　唐時代
Yale University Art Gallery, Gift of John Hadley Cox, B.A. 1935
1940.382a–b

**Section I.
Before Wabi**
Karamono in the Temple
and Shoin

わび以前
寺院と書院での唐物

7.

Tea Bowl
Chinese, 12th–13th century
Jian ware (J. *tenmoku*); stoneware with dark brown glaze, hare's-fur markings in
iron oxide, and lip banded with metal, 2 ⅞ × 5 in. (7.3 × 12.7 cm)
建窯兎毫盞（禾目天目茶碗）中国　南宋時代
Harvard University Art Museums, Arthur M. Sackler Museum, Bequest of David
Berg, Esq.

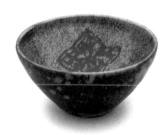

8.

Tea Bowl
Chinese, 12th–13th century
Jizhou ware (J. *tenmoku*); stoneware with dark reserve designs on lighter
variegated field, and tortoiseshell glaze on exterior, 2 ¼ × 4 ¼ in. (5.7 × 10.8 cm)
吉州窯鷓盞（玳皮天目茶碗）中国　南宋時代
Yale University Art Gallery, Gift of Dr. Howard, B.S. 1943, and
Mrs. Carolyn Balensweig
1971.91.3

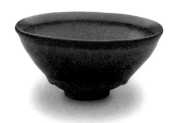

9.

Tea Bowl

Chinese, 13th century

Jian ware (J. *tenmoku*); stoneware with brown glaze and hare's-fur markings in iron oxide, 2½ × 5 in. (6.4 × 12.7 cm)

建窯兔毫盞（禾目天目茶碗）中国　南宋時代

Yale University Art Gallery, Wayland Wells Williams, B.A. 1910, Collection, Gift of Mrs. Frances Wayland Williams

1948.53

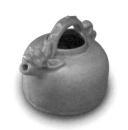

10.

Water Dropper with a Dragon Handle

Chinese, late 13th–early 14th century

Qingbai ware; porcelain with glaze, H. 2⁵⁄₁₆ in. (5.9 cm), w. over handle 3⅛ in. (7.9 cm), DIAM. 2⅜ in. (6 cm)

Historical Note: Collection of a European diplomat, collected in Beijing or Hong Kong, before 1955

青白龍柄付水滴　中国　南宋末〜元時代

Yale University Art Gallery, Purchased with a gift from Alan Kennedy in honor of Schuyler V. R. Cammann, B.A. 1935

2007.113.1

11.

Vase

Chinese, 14th century

Qingbai ware; porcelain with shadow-blue glaze and applied prunus design, 7¾ × 3¹³⁄₁₆ in. (19.7 × 9.7 cm)

青白釉堆梅花瓶　中国　元時代

Yale University Art Gallery, Leonard C. Hanna, Jr., B.A. 1913, Fund

1989.15.1

12.

Vase in the Shape of a Kundika (Water Container for a Buddhist Altar)

Chinese, 14th century

Light gray stoneware with celadon matte glaze, 6⅛ × 1¾ in. (15.6 × 4.5 cm)

緑釉水瓶形花瓶　中国　元時代

Collection of Peggy and Richard M. Danziger, LL.B. 1963

13.

Table Screen

Chinese, 14th–15th century

Longquan ware, Tenryūji type; gray-green crackled glaze over brown stoneware, 6 × 6 ⅝ × 2 ¹⁄₁₆ in. (15.2 × 16.8 × 5.2 cm)

硯屏　龍泉窯天龍寺手　中国　元末～明時代初期

Yale University Art Gallery, Purchased with gifts from Marianne Gerschel, F. Cheney Cowles, B.A. 1966, and an anonymous donor in honor of Dr. Sadako Ohki

2008.119.1

14.

Nobleman's Meal Table (*Kakeban*)

Japanese, ca. 14th–15th century

Negoro ware; red and black lacquer on wood, 6 ⁹⁄₁₆ × 12 ¹³⁄₁₆ × 12 ¼ in. (16.7 × 32.5 × 31.1 cm)

Historical Note: Narita Collection, Japan, before 2002

懸盤　根来塗　室町時代

Yale University Art Gallery, Leonard C. Hanna, Jr., B.A. 1913, Fund

2002.88.1

15.

Footed Stand for a Tea Bowl (*Tenmoku-dai*)

Chinese, 15th century

Carved red over black lacquer on wood, 2 ¹⁵⁄₁₆ × 6 ⁵⁄₁₆ in. (7.5 × 16 cm)

屈輪天目台　漆器　中国　明時代

Collection of Peggy and Richard M. Danziger, LL.B. 1963

16.

After Xia Gui (Chinese, active early 13th century)

River Landscape (*Twelve Views of Landscape*), 15th–16th century

Handscroll; ink on silk, 11 ¼ in. × 17 ft. 3 in. (28.6 × 525.8 cm)

倣夏珪　山水十二景　絹本墨画巻物　中国　明時代

Yale University Art Gallery, The Hobart and Edward Small Moore Memorial Collection, Gift of Mrs. William H. Moore

1953.27.10

17.

Ikkyū Sōjun (Japanese, 1394–1481)
Naming Certificate for "Tagaku," by Ikkyū, 15th century
Hanging scroll; ink on paper, 22 3/16 × 12 11/16 in. (56.4 × 32.2 cm)
Historical Notes: An authentication paper by Kohitsu Ryōga in the
Taishō era (1912–26); another by Kohitsu I (Ryōsa; 1572–1662)
一休宗純　字号「埵嶽」紙本墨書掛幅　室町時代
Collection of Peggy and Richard M. Danziger, LL.B. 1963

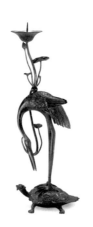

18.

Baiken (Japanese, active late 15th–early 16th century)
White-Robed Kannon, late 15th–early 16th century
Hanging scroll; ink on paper, 28 9/16 × 9 15/16 in. (72.5 × 25.2 cm)
Historical Notes: Professor Moriya Kōzō, purchased June 8, 1932; Setsuda
Hikosuke Collection, 1903, 11th month
梅軒　白衣観音　紙本墨画掛幅　室町時代
Yale University Art Gallery, Purchased with funds from the Japan Foundation
Endowment of the Council on East Asian Studies
2007.107.1

19.

Candle Stand with a Crane and a Tortoise
Japanese, 15th–16th century
Bronze, H. 15 3/4 in. (40 cm)
鶴亀蝋燭台　青銅　室町時代
Property of Mary Griggs Burke

20.

Anonymous, with a seal reading Kanō Motonobu (Japanese, 1476–1559)
Eight Views of the Xiao and Xiang, first half 16th century
Hanging scroll; ink on paper, 17 15/16 × 28 15/16 in. (45.6 × 73.5 cm)
狩野元信印　瀟湘八景　紙本墨画掛幅　室町時代
Yale University Art Gallery, Leonard C. Hanna, Jr., B.A. 1913, Fund
2001.56.1

On view in the Ruth and Bruce Dayton Gallery of Asian Art, on the second floor
of the Yale University Art Gallery.

21.

Octagonal Box

Chinese, ca. 1571

Carved red lacquer with gold and silver pigment, 10 × 11 in. (25.4 × 27.9 cm)

Historical Notes: Susan Dwight Bliss, purchased at auction from William Oastler Collection, on April 10, 1900, at American Art Galleries, N.Y.; Chang family of Zhiangxia, Hubei Province. The box bears an inscription on the base stating that it was acquired by Jiang Xiazhang in the fifth year of the Longqing reign (1571).

堆朱八角食籠　中国　明時代

Yale University Art Gallery, Anonymous gift

1947.174a–b

22.

Inkstone

Chinese, 17th century

Duan stone, 1¾ × 4⅝ × 7⅝ in. (4.5 × 11.8 × 19.4 cm)

端渓硯　中国　明末清初

Yale University Art Gallery, Gift of Robert Hatfield Ellsworth in memory of his mother

1982.2.6a–c

23.

Incense Burner with a Chinese Lion

Japanese, 17th century

Bronze, 5¹¹⁄₁₆ × 3¹⁵⁄₁₆ in. (14.4 × 10 cm)

唐獅子香炉　青銅　江戸時代

Property of Mary Griggs Burke

24.

Brush Rest in the Shape of Mountain Peaks

Chinese, 17th–19th century

Ying limestone with white veining, L. 4½ in. (11.4 cm)

山形筆架　英石　中国　清時代

Yale University Art Gallery, Gift of Robert Hatfield Ellsworth in memory of his mother

1982.2.13

25.

Rock in the Form of a Horizontal Mountainscape with Cavern Heaven
Chinese, 19th–20th century
Gray-black *lingbi* limestone with white veining, 9 ⅜ × 16 ⁹⁄₁₆ × 7 ⅞ in.
(23.9 × 42.1 × 20 cm)
怪石　靈璧石　中国　清末近代
David Drabkin, ʟʟ.ʙ. 1968, Collection

Section II.
Wabi Toriawase
Wabi Inspired by Rikyū

わび取り合わせ
利休のわび世界

Displayed in the exhibition in a portable
teahouse (20th century, anonymous
loan) and in a waiting bench

26.

Square Tray
Chinese, late 12th–early 13th century
Black lacquer over leather body (*shippi*), 1 ⅛ × 8 ¹¹⁄₁₆ × 8 ⁹⁄₁₆ in. (2.9 × 22.1 × 21.7 cm)
八寸盆　漆皮　中国　南宋時代
Collection of Peggy and Richard M. Danziger, ʟʟ.ʙ. 1963

27.

Tea Bowl
Korean, 16th century
Ido ware; stoneware with crackled glaze and a fragment of a Kohiki bowl with
gold lacquer repairs, 3 ¹⁄₁₆ × 6 ³⁄₁₆ in. (7.8 × 15.7 cm)
井戸茶碗　粉引き茶碗金漆直し付き　朝鮮　李朝時代
Promised gift to the Yale University Art Gallery of Peggy and Richard M.
Danziger, ʟʟ.ʙ. 1963

28.

Ceramic Bucket used as a Fresh-Water Jar (Mizusashi)
Japanese, ca. 1570
Shigaraki ware; stoneware with natural ash glaze, 6 ¼ × 7 ¹¹⁄₁₆ in. (15.9 × 19.5 cm)
鬼桶水指　自然灰釉信楽　室町時代
Collection of Peggy and Richard M. Danziger, ʟʟ.ʙ. 1963

29.

Incense Container (Kōgō), originally a Nailhead Cover from Jurakudai Palace

Japanese, ca. 1587

Wood with gold lacquer, 13/16 × 3 1/4 × 3 3/16 in. (2.06 × 8.3 × 8.1 cm)

元聚楽第釘隠し香合　金漆　桃山時代

Collection of Peggy and Richard M. Danziger, LL.B. 1963

30.

Attributed to Raku Chōjirō (Japanese, 1516–1592)

Tea Bowl, named Kaedegure (Twilight by the Maples), late 16th century

Black Raku ware; earthenware with black glaze, 3 9/16 × 4 3/4 in. (9 × 12.1 cm)

伝楽長次郎　黒楽茶碗 銘「楓暮れ」　桃山時代

Promised gift to the Yale University Art Gallery of Peggy and Richard M. Danziger, LL.B. 1963

31.

Sen no Rikyū (Japanese, 1522–1591)

Tea Scoop, 1580s

Bent and carved bamboo, L. 7 1/16 in. (17.9 cm)

Historical Note: Paper *tsutsu* container inscribed on obverse and accompanied by Rikyū's cipher (*kaō*)

千利休　茶杓　竹　桃山時代

Collection of Peggy and Richard M. Danziger, LL.B. 1963

32.

Furuta Oribe (Japanese, 1543–1615)

Flower Container, early 17th century

Bamboo with gold lacquer repair and metal pins, 14 3/16 × 4 × 3 7/16 in. (36 × 10.2 × 8.7 cm)

古田織部　花入れ　竹金漆直し付き　桃山時代

Collection of Peggy and Richard M. Danziger, LL.B. 1963

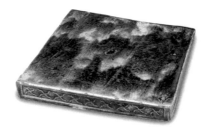

33.

Tile (Shikigawara)

Japanese, early 17th century

Mino ware, Oribe type; stoneware with copper-green glaze,
1 9/16 × 11 1/4 × 11 5/16 in. (4 × 28.6 × 28.7 cm)

敷き瓦　美濃窯織部焼き　桃山時代

Collection of Peggy and Richard M. Danziger, LL.B. 1963

34.

Fishing Weight used as a Kettle Lid Rest (Futaoki)

Japanese, ca. 17th century

Bizen ware; unglazed stoneware, 2 1/2 × 1 7/16 in. (6.4 × 3.7 cm)

蓋置き　備前焼錘　江戸時代

Collection of Peggy and Richard M. Danziger, LL.B. 1963

35.

Sen Sōtan (Japanese, 1578–1658)

"Hangōken" Calligraphy, 1646

Hanging scroll; ink on paper, 20 11/16 × 46 1/16 in. (52.5 × 117 cm)

Historical Notes: The bottom right of the calligraphy bears a handwritten cipher
(*kaō*) by Ryōryōsai Sōsa (Omote Senke IX; 1775–1825); two wrapping papers
bear inscriptions possibly by calligraphy authenticators Kohitsu IX (Ryōi;
1752–1834) and Kohitsu X (Ryōban; 1790–1853) with possible datings, respectively,
of 1801 and 1822

千宗旦　「半合軒」　紙本墨書掛幅　江戸時代

Collection of Peggy and Richard M. Danziger, LL.B. 1963

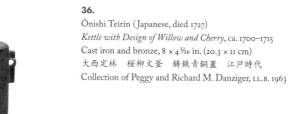

36.

Ōnishi Teirin (Japanese, died 1727)

Kettle with Design of Willow and Cherry, ca. 1700–1715

Cast iron and bronze, 8 × 4 5/16 in. (20.3 × 11 cm)

大西定林　桜柳文釜　鋳鉄青銅蓋　江戸時代

Collection of Peggy and Richard M. Danziger, LL.B. 1963

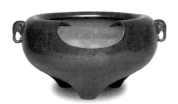

37.

Nishimura Dōya (Japanese, active 1751–64)
Brazier of Otogoze Type, 1751–64
Bronze, 7 5/16 × 13 3/4 in. (18.6 × 34.9 cm)
西村道也　乙御前形風炉　青銅　江戸時代
Collection of Peggy and Richard M. Danziger, LL.B. 1963

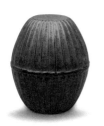

38.

Small Charger used as a Brazier for a Tobacco Tray
Dutch, 18th century
Delft ware; stoneware with overglaze blue decoration on white slip and clear
glaze, 4 5/16 × 3 13/16 in. (11 × 9.7 cm)
煙草用火入れ　デルフト炻器　オランダ　十八世紀
Collection of Peggy and Richard M. Danziger, LL.B. 1963

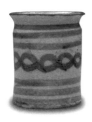

39.

Tobacco Container
Japanese, 19th century
Negoro ware; red over black lacquer on wood, 2 3/8 × 2 3/4 in. (6 × 7 cm)
煙草入れ　根来塗　江戸時代
Collection of Peggy and Richard M. Danziger, LL.B. 1963

40.

Antique Rice Measuring Box used as a Tobacco Tray
Japanese, 19th century
Varnished wood, 3 7/16 × 6 7/8 × 6 9/16 in. (8.7 × 17.5 × 16.7 cm)
米秤用枡　ニス塗り木製　江戸時代
Collection of Peggy and Richard M. Danziger, LL.B. 1963

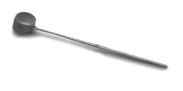

41.
Kuroda Shōgen (Japanese, 1879–1973)
Water Ladle, before 1973
Bamboo, overall 2 ¾ × 16 ⁹⁄₁₆ in. (7 × 42.1 cm)
Historical Note: Acquired directly from the artist's widow in 1979 (this is the last dipper Shōgen made before he fell ill)
黒田正玄　柄杓　竹　昭和時代
David and Eleanor S. Apter Collection

42.
Suzuki Mutsumi (Japanese, born 1942)
Tea Caddy (*Natsume*), ca. 1985
Black lacquer on wood (*shinnuri*), 2 ¹¹⁄₁₆ × 2 ¹¹⁄₁₆ in.
(6.8 × 6.8 cm)
Historical Note: Acquired directly from the artist, ca. 1985
鈴木睦美　棗　真塗り　昭和時代
Collection of Peggy and Richard M. Danziger, LL.B. 1963

43.
Used-Water Container (*Kensui*)
Japanese, 20th century
Bent wood, 2 ⅞ × 6 ½ in. (7.3 × 16.5 cm)
建水　曲物　昭和時代
Collection of Peggy and Richard M. Danziger, LL.B. 1963

Section II.
Wabi Toriawase
Additional Works in the
Wabi Style

わび取り合わせ
茶室外展示わび趣向

44.
Nails from Hōryūji used as Chopsticks for Charcoal
Japanese, 8th century
Iron, L. 10 ⅜ in. (26.3 cm)
炭取り用鉄製箸　元法隆寺建造用釘　奈良時代
Collection of Peggy and Richard M. Danziger, LL.B. 1963

45.

Blue Tang Sake Cup

Chinese, 7th–10th century

Earthenware with cobalt-blue glaze, 2 1/16 × 3 1/16 in. (5.3 × 7.8 cm)

杯　三彩土器　中国　唐時代

Collection of Peggy and Richard M. Danziger, LL.B. 1963

46.

Guan-Ware Incense Container with a Raku Lid and an Added Dragon Handle

Chinese, Japanese, American; 13th century, late 18th century, 20th century

Container: Guan ware with gold repair; lid: Red Raku ware by Raku Kichiza-emon IX (Ryōnyū; 1756–1834), earthenware with glaze; handle: pewter, overall 1 7/8 × 2 5/16 × 2 3/8 in. (4.8 × 5.8 × 6 cm) (with lid)

Historical Note: Private collection, Japan, before 2000

中国元時代金直し付き官香合　楽了入作江戸時代赤楽蓋　アメリカ二十世紀龍形しろめ製柄

Collection of Peggy and Richard M. Danziger, LL.B. 1963

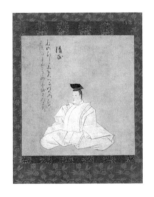

47.

Fujiwara Kiyotada, from the Narikane Version of the Thirty-six Immortal Poets

Japanese, second half 13th century

Section of a handscroll mounted as a hanging scroll; ink and light color on paper, 10 3/8 × 10 1/8 in. (26.4 × 25.7 cm)

Historical Note: Authentication by Kohitsu XII (Ryōetsu; 1831–1894)

業兼本三十六歌仙絵　藤原清正像　紙本淡彩掛幅　鎌倉時代

Collection of Sylvan Barnet and William Burto

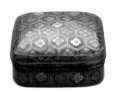

48.

Square Incense Container (Kōgō) with Tortoiseshell Design

Japanese, first half 14th century

Maki-e lacquer on wood with mother-of-pearl inlay and metal rims on box and lid, 1 3/16 × 2 7/16 in. (3 × 6.2 cm)

亀甲文角形蒔絵香合　鎌倉時代

Collection of Peggy and Richard M. Danziger, LL.B. 1963

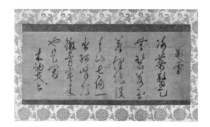

49.

Musō Soseki (Japanese, 1275–1351)

Poem on the Theme of Snow, first half 14th century

Hanging scroll; ink on paper, 11 ¾ × 32 ½ in. (29.9 × 82.6 cm)

Historical Note: Umezawa Memorial Museum, Tokyo

夢窓疎石「雪に題す」紙本墨書掛幅　南北朝時代

Collection of Sylvan Barnet and William Burto

50.

Tonna Hōshi (Japanese, 1289–1372)

Poem by the Monk Tonna, mid-14th century

Hanging scroll; ink on paper with blue cloudlike decoration, 14 ³⁄₁₆ × 2 ³⁄₁₆ in. (36 × 5.5 cm)

頓阿法師　和歌短冊　紙本墨書掛幅　南北朝時代

Collection of Peggy and Richard M. Danziger, LL.B. 1963

51.

Zekkai Chūshin (Japanese, 1336–1405)

"There Is No One in the Mountain . . . ," last quarter 14th century

Hanging scroll; ink on paper, 34 ½ × 8 ⅝ in. (87.6 × 21.9 cm)

Historical Note: A certificate (*kiwame fuda*) dated 1761 by Kohitsu VII (Ryōen; 1705-1774)

絶海中津　「山空にして松子落つ」　紙本墨書掛幅　室町時代

Collection of Sylvan Barnet and William Burto

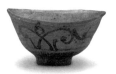

52.

Tea Bowl

Korean, 15th–16th century

Buncheong ware; stoneware with slip and iron-brown overglaze decoration, 3 ¹⁄₁₆ × 6 ¼ in. (7.8 × 15.8 cm)

Historical Note: Box lid reverse writing records that Masuda Don'ō (Takashi; 1848–1938) acquired the bowl in 1928 from Mr. Sumii

刷毛目茶碗　朝鮮　李朝時代

Collection of Peggy and Richard M. Danziger, LL.B. 1963

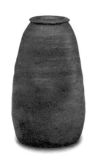

53.
Hanging Flower Vase
Japanese, 16th century
Old Bizen ware; unglazed stoneware, 6 ⅞ × 3 ⁹⁄₁₆ in. (17.5 × 9 cm)
Historical Note: The vase surface bears the cipher (*kaō*) of Sen
Sōtan (1578–1658) in red pigment.
掛け花入れ　古備前　室町時代
Collection of Peggy and Richard M. Danziger, ʟʟ.ʙ. 1963

54.
Sen no Rikyū (Japanese, 1522–1591)
Letter, ca. 1583
Hanging scroll; ink on paper, 11 × 20 ¾ in. (28 × 52.7 cm)
Historical Note: A handwritten transcription of the text by Tayama Hōnan
(1903–1980) identified the addressee as a certain Sōwa, but Komatsu Shigemi
(born 1925) reidentified as Sōyū (unknown friend of Rikyū)
千利休　宗裕宛手紙　紙本墨書掛幅　1583 年頃　桃山時代
Collection of Peggy and Richard M. Danziger, ʟʟ.ʙ. 1963

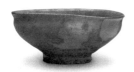

55.
Tea Bowl, Kohiki- or Muji Hakeme–Type
Korean, second half 16th century
Stoneware with white slip and transparent glaze with gold lacquer repair,
2 ¹⁵⁄₁₆ × 6 ⁵⁄₁₆ in. (7.5 × 16 cm)
粉引き又は無地刷毛目茶碗　金漆直し付き　朝鮮　李朝時代
Promised gift to the Yale University Art Gallery of Peggy and Richard M.
Danziger, ʟʟ.ʙ. 1963

56.
*Tenmyō-Type Kettle, known as Taya Itome (Kettle with Thread Pattern at the
Taya House)*
Japanese, 16th century
Cast iron, 6 ⅞ × 11 ⁷⁄₁₆ in. (17.5 × 29 cm)
Historical Notes: Masuda Don'ō (1847–1938); accompanying square white cloth
records in *sumi* ink that the "Taya" was owned by Sen no Rikyū, before 1591
天明釜銘「田屋糸目」鋳鉄　室町末～桃山時代
Collection of Peggy and Richard M. Danziger, ʟʟ.ʙ. 1963

57.
Fresh-Water Jar (*Mizusashi*), *named Mino* (*Straw Rain Cape*)
Japanese, late 16th century
Mino ware, Yellow Seto type; stoneware with yellow, oxidized, ash glaze and a
round lid of lacquer on wood, 6 ⅝ × 5 ⁷⁄₁₆ in. (16.8 × 13.8 cm)
Historical Note: Bears a cipher (*kaō*) "Kazen" (unidentified)
水指 銘「蓑」　漆蓋付き美濃窯黄瀬戸　桃山時代
Collection of Peggy and Richard M. Danziger, LL.B. 1963

58.
Seta Kamon (Japanese, died 1595)
Tea Scoop, 16th century
Bent and carved bamboo, L. 7 ½ in. (19 cm)
Historical Notes: Outermost box lid reverse bears an authentication by
Sokuchūsai (1901–1979; Omote Senke XIII); outer box bears a description signed
by Kohitsu Ryōban (1790–1853; Kohitsu X); case (*tsutsu*) signed by Kakukakusai
(1678–1730; Omote Senke VI)
瀬田嘉門　茶杓　竹　桃山時代
Collection of Peggy and Richard M. Danziger, LL.B. 1963

59.
Mirror Box used as an Incense Container (*Kōgō*)
Japanese, early 17th century
Kōdaiji-style *maki-e*; lacquer on wood, 1 ¾ × 3 ¹⁵⁄₁₆ in.
(4.5 × 10 cm)
高台寺蒔絵香合　桃山時代
Collection of Peggy and Richard M. Danziger, LL.B. 1963

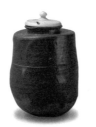

60.
Shinbei (Japanese, active late 16th–early 17th century)
Eggplant-Shaped Tea Caddy (*Cha-Ire*), *named Shira Tsuyu*
(*White Dew*), 17th century
Seto ware; stoneware with iron glaze and an ivory lid, 7 ¾ ×
2 ¹⁵⁄₁₆ in. (19.7 × 7.5 cm)
Historical Note: Matsunaga Jian (1875–1971) Collection
新兵衛　瀬戸茶入れ銘「白露」象牙蓋付き鉄釉　桃山時代
Collection of Peggy and Richard M. Danziger, LL.B. 1963

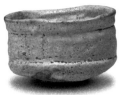

61.

Tea Bowl, named Onigawara (Demon Tile)
Japanese, early 17th century
Mino ware, Shino type; stoneware with white glaze, 3 ½ × 5 ⁷/₁₆ in. (8.9 × 13.8 cm)
Historical Notes: "Onigawara" was written in red lacquer directly on the bowl
next to the foot, but now the writing has flaked off and is unclear. A paper
insert bears the name "Onigawara" accompanied by an impression of the *kaō* of
Zuiryūsai (Omote Senke V). A sheet of *washi* paper attached to the reverse of the
inner box lid states, "Shino-yaki chawan Zuiryū mei wonikahara nani mo migoto
gohizō narubeku sōrō. fugu Kakukaku [*kaō*]" (Shino tea bowl with auspicious
name "Demon Tile" is excellent. I do hope you will treasure it. Sincerely,
Kakukakusai [Omote Senke VI; cipher]). Matsunaga Jian (1875–1971) Collection
茶碗 銘「鬼瓦」美濃窯白釉志野焼き　桃山時代
Collection of Peggy and Richard M. Danziger, LL.B. 1963

62.

Tea Bowl Decorated with Dragon Medallions
Chinese, 17th century
Porcelain with glaze and underglaze blue, *sometsuke* type, 2 ⁷/₈ × 5 ⁵/₈ in.
(7.3 × 14.3 cm)
茶碗　龍丸文下絵染付磁器　中国　明時代
Collection of Peggy and Richard M. Danziger, LL.B. 1963

63.

Annamese Tea Bowl
Vietnamese, ca. 17th century
Stoneware with glaze and underglaze cobalt-blue decoration, 3 ⁹/₁₆ × 4 ½ in.
(9 × 11.5 cm)
Historical Note: John A. Pope Collection, before 1978
安南茶碗　藍下絵染付け炻器　ヴエトナム　十七世紀
Collection of Peggy and Richard M. Danziger, LL.B. 1963

64.

Tea Bowl
Japanese, early 17th century
Shigaraki ware; stoneware with natural ash glaze, 3 ¹³/₁₆ × 3 ¼ in. (9.7 × 8.3 cm)
Historical Note: Name of previous owner inscribed on paper label on side of
storage box (undecipherable)
茶碗　自然灰釉信楽焼き　桃山時代
Collection of Peggy and Richard M. Danziger, LL.B. 1963

65.

Fresh-Water Jar (Mizusashi), named Hotei

Japanese, ca. 1600

Iga ware; stoneware with natural ash glaze, 7 ½ × 6 ⅞ in. (19 × 17.5 cm)

Historical Notes: Box writing by Sumiyama Yōho (died 1783) from Osaka, student of Joshinsai (1706–1751; Omote Senke VII); also paper record by Joshinsai

水指　銘「布袋」自然灰釉伊賀焼き　桃山時代

Collection of Peggy and Richard M. Danziger, LL.B. 1963

66.

Set of Dishes (Mukōzuke)

Japanese, ca. 1600

Mino ware, Yellow Seto type; stoneware with yellow glaze, each 2 ⅜ × 3 ⁵⁄₁₆ in. (6 × 8.4 cm)

Historical Note: Fujita Museum, Osaka, before 1981

向付　美濃窯黄瀬戸　桃山時代

Collection of Peggy and Richard M. Danziger, LL.B. 1963

67.

Rectangular Plate

Japanese, late 16th–early 17th century

Mino ware, Gray Shino type; stoneware with slip and glaze and incised design, 8 ¹³⁄₁₆ × 7 ¹¹⁄₁₆ in. (22.4 × 19.6 cm)

皿　美濃窯鼠志野焼き　桃山時代

Collection of Peggy and Richard M. Danziger, LL.B. 1963

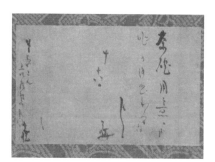

68.

Hon'ami Kōetsu (Japanese, 1558–1637)

Letter to Raku Kichizaemon, ca. 1615–35

Hanging scroll; ink on paper, 10 ¹³⁄₁₆ × 17 ¹¹⁄₁₆ in. (27.5 × 45 cm)

Historical Note: A wooden box dated (1967) and signed by Kumazawa Goroku, a former director of the Tokugawa Art Museum, for an appreciation record; a handwritten letter of appreciation from Komatsu Shigemi, director of Century Art Museum, Tokyo

本阿弥光悦　楽吉左衛門宛手紙　紙本墨書掛幅　江戸時代

Collection of Peggy and Richard M. Danziger, LL.B. 1963

69.

Nonomura Ninsei (Japanese, ca. 1620–ca. 1695)
Incense Container (Kōgō) in the Shape of a Wisteria Seedpod, before 1656
Stoneware with underglaze iron decoration, 1 × 5 in. (2.5 × 12.7 cm)
Historical Note: Records state it comes with box believed to be inscribed by
Kanamori Sōwa (1584–1656)
野々村仁清　錆絵藤豆香合　京焼　1656年以前　江戸時代
Collection of Peggy and Richard M. Danziger, LL.B. 1963

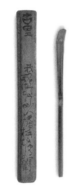

70.

Kobori Enshū (Japanese, 1579–1647)
Tea Scoop, named Furusato (Hometown), first half 17th century
Bent and carved bamboo, L. 7 1/16 in. (18 cm)
Historical Notes: The box lid reverse bears authentication by Kohitsu VII (Ryōen;
1705–1774); box inscription by Kobori Daizen (*kaō*); outer box inscription by
Kobori Sōkei (1620–1674, second head of Enshū school)
小堀遠州　茶杓　銘「古里」竹　桃山～江戸時代初期
Collection of Peggy and Richard M. Danziger, LL.B. 1963

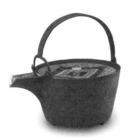

71.

Sake Pourer with Kutani-Ware Lid
Japanese, 17th century
Cast-iron body with incised pattern and with Kutani-ware
lid of porcelain with overglaze decoration, 6 1/8 × 6 11/16 in.
(15.5 × 17 cm)
酒次　色絵付け九谷焼き蓋付き鋳鉄　江戸時代
Collection of Peggy and Richard M. Danziger, LL.B. 1963

72.

Rectangular Serving Plates (Mukōzuke)
Japanese, 17th century
Arita ware, Blue Kutani type (Ai-Kutani); porcelain with
underglaze blue pattern, 15/16 × 5 13/16 × 3 7/16 in.
(2.4 × 14.8 × 8.8 cm)
向付　藍九谷下絵付け有田焼　江戸時代
Collection of Peggy and Richard M. Danziger, LL.B. 1963

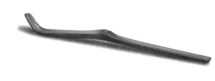

73.

Daishin Gitō (Japanese, 1656–1730)

Tea Scoop, named Hyakusai (*One Hundred Years Old*),
early 18th century

Bent and carved bamboo, L. 6 15/16 in. (17.6 cm)

Historical Notes: The bamboo cylinder (*tsutsu*) obverse is inscribed by Daishin;
inner box lid reverse bears inscription and cyclical date, perhaps corresponding to
1922, and signature "Kojakusō" accompanied by a round seal reading "Kōsai," both
identified as Ōkura Kōsai (active late 19th–early 20th century)

大心義統　茶杓 銘「百歳」　竹　江戸時代

Collection of Peggy and Richard M. Danziger, LL.B. 1963

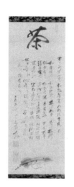

74.

Daishin Gitō (Japanese, 1656–1730)

Treatise on Tea, signed 1729

Hanging scroll; ink on paper, 25 9/16 × 10 1/4 in. (64.9 × 26.1 cm)

Historical Note: The calligraphy bears the large character for "tea" at the center
top, followed by four major words, *wa kei sei jaku*, meaning "harmony, respect,
purity, and tranquility," with some explanation.

大心義統　茶の心得　紙本墨書掛幅　江戸時代

Collection of Peggy and Richard M. Danziger, LL.B. 1963

75.

Tin-Glazed Sake Cup

Dutch, 17th–18th century

Stoneware with tin glaze and floral decoration in blue, green, and orange,
1 3/4 × 2 3/8 in. (4.5 × 6 cm)

オランダ製酒杯　花柄色絵付け　十七〜十八世紀

Collection of Peggy and Richard M. Danziger, LL.B. 1963

76.

Incense Container (*Kōgō*) *with Kōrin-Style Design*

Japanese, 18th century

Lacquer on wood with mother-of-pearl, gold, and pewter decoration,
1 3/4 × 3 5/8 in. (4.5 × 9.2 cm)

光琳様香合　阿古屋貝金しろめ装飾蒔絵　江戸時代

Collection of Peggy and Richard M. Danziger, LL.B. 1963

77.

Tea Caddy (Cha-Ire) of Kinrinji Type
Japanese, 17th–19th century
Wisteria, 3 ⅛ × 2 ½ in. (7.9 × 6.3 cm)
金輪寺茶入れ　藤蔓　江戸時代
Collection of Peggy and Richard M. Danziger, LL.B. 1963

78.

Charcoal Basket (Sumitori)
Japanese, late 19th–early 20th century
Bamboo and cane, 4 ¾ × 9 ¹³⁄₁₆ in. (12 × 25 cm)
炭取り籠　竹と藤　明治時代
Collection of Peggy and Richard M. Danziger, LL.B. 1963

79.

Koshida Bizan (Japanese, born 1874)
Moon-Shaped Incense Container (Kōgō), late 19th–early 20th century
Maki-e lacquer on wood, ¹³⁄₁₆ × 2 ⅛ in. (2.06 × 5.4 cm)
越田美山　月香合　蒔絵　明治大正時代
Collection of Peggy and Richard M. Danziger, LL.B. 1963

80.

Masuda Copy of Rikyū-Owned Fish Basket Used as a Flower Vase
Japanese, 1927
Woven bamboo, 11 × 15 in. (27.9 × 38.1 cm)
Historical Note: Masuda Don'ō (Takashi; 1848–1938) had a basketmaker
make seven copies, and this is one of them
倣利休所持花入れ　益田鈍翁依頼製作の内　昭和時代
Collection of Peggy and Richard M. Danziger, LL.B. 1963

81.

Tsuji Seimei (Japanese, 1927–2008)
Used-Water Container (Kensui), ca. 1980
Shigaraki ware; stoneware with natural ash glaze,
H. 4 ⅛ in. (10.5 cm), DIAM. 6 ⅛ in. (15.6 cm)
辻清明　建水　自然灰釉信楽焼き　昭和時代
Collection of Peggy and Richard M. Danziger, LL.B. 1963

82.

Sugimoto Sadamitsu (Japanese, born 1935)
Sake Cup in the Style of Kōetsu, late 20th century
Red Raku ware; red earthenware with glaze, 2 ½ × 3 ⅛ in. (6.3 × 7.8 cm)
杉本貞光　光悦様ぐい呑み　赤楽　昭和時代
Collection of Peggy and Richard M. Danziger, LL.B. 1963

83.

Suzuki Mutsumi (Japanese, born 1942)
Set of Bowls with Lids, ca. 1985
Lacquer on wood, small bowl 2 × 4 ¹³⁄₁₆ in. (5.1 × 12.2 cm);
small bowl lid 1 ¾ × 4 ⁷⁄₁₆ in. (4.4 × 11.3 cm); large bowl 2 ¾ × 5 ³⁄₁₆ in. (7 × 13.2 cm);
large bowl lid 2 ⅜ × 4 ¹⁵⁄₁₆ in. (6.1 × 12.6 cm)
Historical Note: Acquired directly from the artist, ca. 1985
鈴木睦美　懐石用蓋付き椀一対　真塗　昭和時代
Collection of Peggy and Richard M. Danziger, LL.B. 1963

84.

Raku Kichizaemon XV (Japanese, born 1949)
Flower Vase of Uzukumaru Type, 1985
Raku ware; unglazed earthenware, 5 ¹⁄₁₆ × 4 ⁹⁄₁₆ in. (12.8 × 11.6 cm)
Historical Notes: Acquired directly from the artist; exhibited at the Jūbikai, an
exhibition of works by the ten traditional purveyor families of utensils to the
three Sen lineages (Senke Jisshoku)
十五代楽吉左衛門　蹲花入れ　楽焼き　昭和時代
Collection of Peggy and Richard M. Danziger, LL.B. 1963

85.

Tsujimura Shirō (Japanese, born 1947)
Tea Bowl, ca. 2003
Mino-style ware, *hikidashiguro* type; stoneware with black glaze,
3 9/16 × 4 7/8 in. (9.1 × 12.4 cm)
辻村史朗　茶碗　美濃風引き出し黒　平成時代
Collection of Peggy and Richard M. Danziger, LL.B. 1963

86.

Covered Jar used as a Tea Caddy (Cha-Ire)
Chinese, 10th–13th century
Porcelain with iron-based glaze, 2 3/8 × 1 15/16 in. (6 × 5 cm)
Historical Note: Kitaōji Rosanjin (1883–1959) Collection, before
1959, used as cigarette case
茶入れ　鉄釉磁器　中国　宗時代
Collection of Peggy and Richard M. Danziger, LL.B. 1963

**Section III.
Continuity and Change:
A Modern Toriawase**

継承と変化：
現代の取り合わせ

87.

Used-Water Container (Kensui)
Chinese, 16th century
Copper alloy (*sawari*), 2 1/16 × 6 5/16 in. (5.3 × 16 cm)
建水　鼓銅器（砂張）中国　明時代
Collection of Peggy and Richard M. Danziger, LL.B. 1963

88.

Pair of Sake Flasks
Japanese, late 16th century
Maki-e lacquer on wood with gold in Kōdaiji style, H. 8 in. (20.3 cm)
徳利　高台寺蒔絵　桃山時代
Collection of Peggy and Richard M. Danziger, LL.B. 1963

89.
Lacquer Stand, Ryūkyū Style
Okinawan, 16th–17th century
Lacquer on wood with mother-of-pearl, 19 ½ × 12 ³⁄₁₆ × 9 ⅝ in. (49.5 × 31 × 24.5 cm)
琉球様蒔絵棚　阿古屋貝装飾漆器　沖縄　十六～十七世紀
Collection of Peggy and Richard M. Danziger, LL.B. 1963

90.
Fresh-Water Jar (Mizusashi) of Madara-Garatsu Type
Japanese, ca. 1600
Karatsu ware; stoneware with straw ash glaze and gold repair at rim, 5 ³⁄₁₆ × 4 ⅝ in. (13.2 × 11.7 cm)
斑唐津水指　唐津焼金直し付き　桃山時代
Collection of Peggy and Richard M. Danziger, LL.B. 1963

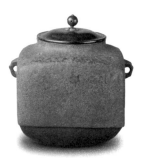

91.
Attributed to Nishimura Kuhei (Japanese, active 1600–1658)
Square Kettle, ca. 1600–1658
Cast iron, 7 ½ × 4 ½ × 6 ⅞ in. (19 × 11.5 × 17.5 cm)
Historical Notes: The box lid obverse records it was made by Nishimura Kuhei of Sōtan's time but unidentified Onishi Seiemon records it was made by Jōmi (died 1722)
伝西村九兵衛　四方釜　鋳鉄　桃山～江戸時代初期
Collection of Peggy and Richard M. Danziger, LL.B. 1963

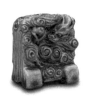

92.
Kettle Lid Rest (Futaoki) with Dragon Design
Japanese, 18th century
Stoneware with Oribe-green glaze, 2 ⁹⁄₁₆ × 1 ³⁄₁₆ × 2 ⁹⁄₁₆ in. (6.5 × 3 × 6.5 cm)
龍柄蓋置き　緑釉織部焼き　江戸時代
Collection of Peggy and Richard M. Danziger, LL.B. 1963

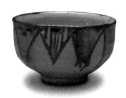

93.
Hamada Shōji (Japanese, 1894–1978)
Tea Bowl with Okinawan-Style Decoration, ca. 1930
Stoneware of brown clay with white slip and clear glaze, decorated in underglaze
cobalt blue and iron with overglaze green and red enamels, 2 15/16 × 4 in.
(7.5 × 10.1 cm)
浜田庄司　色絵付け沖縄風茶碗　昭和時代
Collection of Peggy and Richard M. Danziger, LL.B. 1963

94.
Suzuki Mutsumi (Japanese, born 1942)
Hearth Frame (Robuchi), ca. 1981–82
Maki-e lacquer on wood, 16 9/16 × 16 9/16 in. (42 × 42 cm)
鈴木睦美　炉縁　蒔絵　昭和時代
Collection of Peggy and Richard M. Danziger, LL.B. 1963

95.
Tsuji Seimei (Japanese, 1927–2008)
Incense Container (Kōgō), 20th century
Iga ware; stoneware with natural ash glaze, 1 7/8 × 2 1/16 in. (4.7 × 5.3 cm)
辻清明　香合　自然灰釉伊賀焼き　昭和時代
Collection of Peggy and Richard M. Danziger, LL.B. 1963

96.
Lee Lee-Nam (Korean, born 1969)
Inspired by an original ink painting by Kim Hong-do (1745–1806)
Bamboo in Snow, 2006
Single-channel video (transferred to DVD) on a 42-in. (106.7 cm) monitor,
3 minutes run time, edition 2 of 6, 30 × 56 × 4 in. (76.2 × 142.2 × 10.2 cm)
(with frame)
李　二男　雪竹　倣金弘道墨竹図　三分ヴィデオ　2006年
Courtesy of KooNewYork and Lee Lee-Nam

CHINA

SEA OF

JAPAN

GYERYONGSAN

South
Chungcheong
Province

(Keiryūsan)

KOREA

KUTANI

KYOTO

SHIGARAKI

BIZEN

Nagano
Prefecture

HAGI

Lake
Biwa

SETO

MINO

HON

KARATSU

IGA

Owari
Province

Yam
Pre

Nagasaki

SHIKOKU

Mikawa
Province

KYUSHU

Osaka

Negoroji

Sakai

Nara

Nagoya

Tanegashima

PAC

OKINAWA

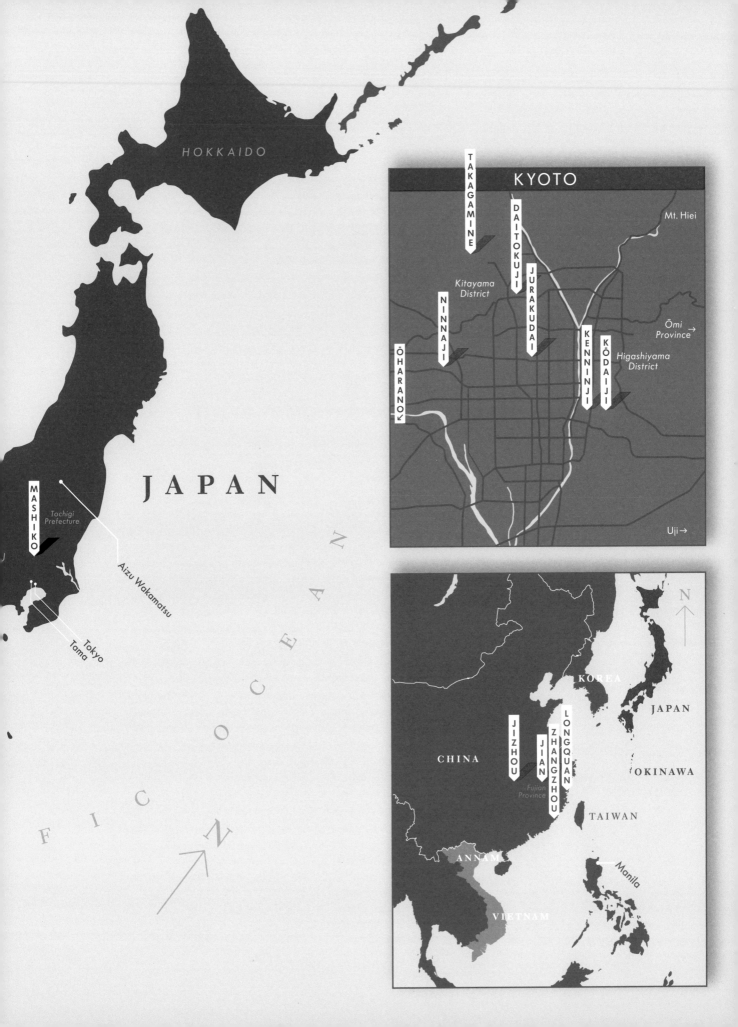

HOKKAIDO

JAPAN

MASHIKO

Tochigi
Prefecture

Aizu Wakamatsu

Tokyo

Tama

PACIFIC OCEAN

KYOTO

TAKAGAMINE

DAITOKUJI

JURAKUDAI

Mt. Hiei

Kitayama
District

NINNAJI

Ōmi
Province →

ŌHARANO

KENNINJI

KŌDAIJI

Higashiyama
District

Uji →

N

KOREA

JAPAN

CHINA

OKINAWA

JIZHOU

JIAN

ZHANGZHOU

LONGQUAN

Fujian
Province

TAIWAN

ANNAM

Manila

VIETNAM

N

Glossary

BASARA 婆娑羅: A Buddhist-derived term that describes a flamboyant style associated with daimyo of the Muromachi and Momoyama periods. It featured exotic goods and decadent behavior.

BIZEN 備前: An ancient type of Japanese stoneware without glazes except for ash, traditionally made around Imbe village, Okayama Prefecture, Honshu. When fired, the clay takes on a rich, reddish-brown color, and accumulations of ash produce blue and gray effects on the surface. The Bizen wares produced during the sixteenth and seventeenth centuries are called "Old Bizen" (Ko Bizen), which are particularly esteemed among tea connoisseurs.

BUKE 武家: Military class (samurai).

BUNCHEONG: The Korean term (J. 粉青) for a stoneware produced in Korea in the fifteenth and sixteenth centuries. The Japanese distinguish a number of classifications within the group, such as Ido, Hakeme, and Kohiki or Muji-Hakeme.

CHADŌ 茶道: An alternate reading of *sadō*, literally "the way of tea."

CHA-IRE 茶入れ: Tea caddy, a container for powdered tea (of ceramic for thick tea and of lacquer for thin tea, though this term is usually used to refer to the former).

CHANOYU 茶の湯: Literally "hot water for tea," the Japanese term used to refer to the Japanese tea culture that emerged during the Muromachi period.

CHASEN 茶筅: Tea whisk.

CHASHAKU 茶杓: Tea scoop.

CHASHITSU 茶室: Tea room.

CHAWAN 茶碗: Tea bowl.

CHŌNIN 町人: Merchants; merchant class, literally "townspeople."

DAIMYO 大名: Literally "big names," the warlords who ruled over a politically fragmented Japan, especially from the late fifteenth century to 1600.

DŌBŌSHŪ 同朋衆: Companions to the Ashikaga shoguns, they served as curators, and interior and exterior designers, as well as servants.

FURO 風炉: Brazier, used from May through October.

FUTAOKI 蓋置き: Rest for the lid of a kettle (and for the water ladle).

GEKOKUJŌ 下克上: Literally "the lower ruling the upper," a term used to describe the social and political situation of the mid- to late Muromachi period.

GOSU 呉須: A blue color used for underglaze decoration consisting of impure asbolite, containing cobalt and manganese mixed with iron.

HAGI 萩: A Japanese type of stoneware produced since the seventeenth century around Hagi, Yamaguchi Prefecture, Honshu. The initial potters were Koreans, hence the close connection to Korean Buncheong ware.

HAKEME 刷毛目: Brushed pattern; also, a type of ware with the pattern.

HANA-IRE 花入れ: Flower container.

HIGAKIMON 桧垣文: "Fence pattern," often appearing on Shino ware.

HISHAKU 柄杓: Water ladle.

HIKIDASHIGURO 引き出し黒: Literally, "pulled-out or drawn-out black," a technique developed at the Mino kilns and adopted by Raku Chōjirō and other potters to produce a black-glazed ware by "pulling out" a piece from the kiln during firing to produce reduction.

IDO 井戸: A Japanese term for a type of Korean bowl traditionally thought to have originated among peasants and used for tea in *chanoyu*.

KABUKI 歌舞伎: A word derived from *kabuku*, "to slant," meaning to act with extraordinary manner to attract attention. This later became the name for a theatrical style fashionable in the Edo period and continuing today.

KAISEKI 懐石: A simple but elegant meal taken before the serving of tea at a formal tea gathering.

KAMA 釜: Kettle.

KAŌ 花押: "Cipher," most often a handwritten personal signature in a highly stylized form, popular among the ruling class and art connoisseurs for verifying an authentication.

KARAMONO 唐物: "Chinese things," used to describe imported objects from China and Southeast Asia with foreign flavor.

KARATSU 唐津: A type of Japanese stoneware with strong Korean influences produced in Karatsu, Saga Prefecture, Kyushu.

KENSUI 建水: Used-water container.

KŌDAI 高台: The foot of a tea bowl, a point of appraisal as it often shows the color and the quality of the original clay body.

KŌGŌ 香合: Incense container.

KŌRAIMONO 高麗物: "Korean things," usually used to refer to imports from the mid-sixteenth century that exhibited the new taste for an impoverished, rough aesthetic.

KŌRO 香炉: Incense burner.

KUGE 公家: Nobility; aristocratic class.

MACHIAI 待合: Covered bench for guests waiting for the host's call.

MADARA-GARATSU 斑唐津: "Mottled Karatsu," a type of Karatsu ware from Kyushu that has an uneven layer of grayish-white glaze produced by ash glaze over dark brown glazes.

MATCHA 抹茶: Ground, powdered green tea whipped in hot water that is drunk directly, not steeped as in other kinds of tea. Used in Japanese tea practice.

MINO 美濃: North of Nagoya in the south of Gifu Prefecture, Mino was a major center of stoneware production in medieval Japan. Mino wares include Shino, Yellow and Black Seto, and Oribe.

MIZUSASHI 水指: Fresh-water jar.

MUKŌZUKE 向付: A side dish placed beyond (*mukō*) the set of rice and soup bowls at a *kaiseki* meal.

NATSUME 棗: A tea caddy most often made of lacquer on wood, frequently used for thin tea.

NEGORO LACQUER/WARE 根来塗り: Lacquer ware of either red or black or the combination of the two produced originally at the Negoroji temple in Wakayama Prefecture, Honshu, during the medieval period. Its simple form and style were later treasured by tea aficionados.

NŌ (NOH) 能: A dramatic art form patronized especially by the ruling warrior class during the Muromachi period.

ORIBE WARE 織部焼き: A type of Mino ware that bears the name of Furuta Oribe (1543–1615), as it is thought to have reflected his adventurous taste. It has prominent colors of green and black.

RAKU 楽: A type of low-fired pottery entirely handmade without any surface decoration, named after Raku Chōjirō (1516–1592), the reputed founder of the tradition. Many connoisseurs value Raku the highest among tea bowls.

RENGA 連歌: The most important form of poetry during the Muromachi period. It was composed sequentially with each participant composing linking verses and could go on for many rounds.

RO 炉: Hearth, used from November to early May.

RYŪKOTSU 竜骨: Literally "dragon bones," a design that resembles them.

RYŪREISHIKI 立礼式: Traditional *matcha* prepared in a Western-style seated position on chairs at a table.

SADŌ 茶道: An alternate reading for *chadō*, literally "the way of tea."

SAREI 茶礼: Literally "tea manners," a protocol for the making and drinking of tea that emerged in Zen temples and formed the foundation for later tea practice.

SENCHA 煎茶: Steeped, leaf tea.

SENKE 千家: The name of Sen family lineages of *chanoyu* practitioners ("schools"), of which there are three: Omote Senke, Ura Senke, and Mushanokōji Senke, each headed by successive generations (*iemoto*, "head of house/line").

SETO 瀬戸: A kiln site near Nagoya that is still the center of the largest pottery-producing region in Japan. Seto and Mino kilns are sometimes conflated, as they are geographically adjacent, but Seto is the older tradition, dating to the twelfth century. The products of Seto kilns should not be confused with Yellow Seto and Black Seto wares (Ki-Seto and Setoguro), which are products of the Mino kilns.

SHIFUKU 仕覆: Cloth bag for a tea caddy.

SHIGARAKI 信楽: A pottery site in southeastern Kyoto famous for its unglazed stoneware of coarse clay with high contents of feldspar and quartz that produce olive-green runs over the rough reddish body.

SHIKIGAWARA 敷瓦: Tile or lacquer board placed under a brazier.

SHINO 志野: A ceramic ware produced in Mino famous for its thick white glaze and a gray glaze with sgraffito technique.

SHIPPI 漆皮: Lacquer work over leather (rather than wood).

SHOIN 書院: A study in a formal Japanese residence. It was first used to study Chinese art objects, and became the room in which to have tea while appreciating art. Classically characterized by a window-adjacent desk, staggered shelves, and *tokonoma* alcove for object display.

SŌAN 草庵: A thatched-roof hut. Tea houses in this form, which imitated rustic farmhouses, became the context for the *wabi*-style of tea.

SUMITORI 炭取り: Charcoal basket.

TATAMI 畳: Straw mat.

TENMOKU 天目: Japanese term for Chinese Jian- and Jizhou-ware tea bowls treasured the most by tea aficionados for their perfect conical shape, with black or brown-black glaze and often with complicated surface design of hare's fur and oilspotlike pattern.

TOBACCO ACCOUTREMENTS 煙草盆セット: A tray, tobacco container, brazier, and pipe make up the set, which is often placed at the covered waiting bench for guests before entering the tea room.

TŌCHA 闘茶: Tea contests in which participants tried to determine the origins of various teas. These contests featured expensive, imported goods for prizes and were the rage in the fifteenth century.

TOKONOMA 床の間: An alcove for display. In tea, it is used for a grouping of a hanging artwork that most often defines the purpose of the gathering, a flower container, and an incense container.

TORIAWASE 取り合わせ: The selecting and arranging of tea objects fit for a particular tea gathering, since different occasions prompt various combinations.

TSUKUBAI 蹲踞: An exterior water basin used by guests to purify themselves before entering the tea room.

WABI わび: An aesthetic that valorizes beauty in the impoverished and imperfect.

WABICHA わび茶: *Chanoyu* based on the *wabi* aesthetic.

WAKA 和歌: Traditional Japanese poems in thirty-one syllable form.

WAMONO 和物: "Japanese things," used to describe the native wares that demonstrated *wabi* taste, which emerged during the late 1580s.

WARIKŌDAI 割り高台: High notched foot.

Tea Arrangement

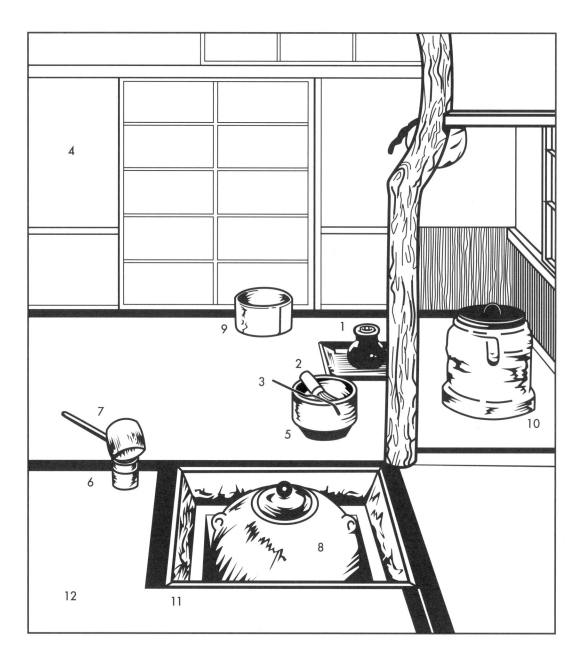

Further Reading

IN ENGLISH:

Berry, Mary Elizabeth. *The Culture of Civil War in Kyoto*. Berkeley: University of California Press, 1994.

Cort, Louise. "The Kizaemon Teabowl Reconsidered: The Making of a Masterpiece." *Chanoyu Quarterly* 71 (1992): 7–30.

Guth, Christine. *Art, Tea, and Industry: Masuda Takashi and the Mitsui Circle*. Princeton, N.J.: Princeton University Press, 1993.

Hayashiya, Tatsusaburo, Masao Nakamura, and Seizo Hayashiya. Translated and adapted by Joseph P. Macadam. *Japanese Arts and the Tea Ceremony*. New York: Weatherhill; Tokyo: Heibonsha, 1974.

Hickman, Money L. et al. *Japan's Golden Age: Momoyama*. Dallas: Dallas Museum of Art, 1996.

Hirota, Dennis. *The Wind in the Pines*. Fremont, Calif.: Asian Humanities Press, 1995.

Isozaki, Arata, Tadao Ando, and Terunobu Fujimori. *The Contemporary Tea House: Japan's Top Architects Redefine a Tradition*. New York: Kodansha International, 2007.

Kumakura Isao and Paul Varley. *Tea in Japan*. Honolulu: University of Hawaii Press, 1989.

Pitelka, Morgan. *Handmade Culture: Raku Potters, Patrons, and Tea Practitioners in Japan*. Honolulu: University of Hawaii Press, 2005.

Pitelka, Morgan, ed. *Japanese Tea Culture: Art, History, and Practice*. London: Routledge Curzon, 2003.

Rousmaniere, Nicole Coolidge, ed. *Kazari: Decoration and Display in Japan 15th–19th Centuries*. New York: Japan Society, 2002.

Sen Sōshitsu. *The Japanese Way of Tea: From Its Origins in China to Sen no Rikyū*. Honolulu: University of Hawaii Press, 1998.

Shimizu, Yoshiaki, and John M. Rosenfield. *Masters of Japanese Calligraphy 8th–19th Century*. New York: The Asia Society Galleries and Japan House Gallery, 1984.

Souyri, Pierre. *The World Turned Upside Down: Medieval Japanese Society*. New York: Columbia University Press, 2001.

Tanaka, Sen'ō, and Sendō Tanaka. *The Tea Ceremony*. New York: Kodansha International, rev. ed. 2000.

IN JAPANESE:

Akasegawa Genpei. *Sen no Rikyū: Mugon no zen'ei* (*Sen no Rikyū: Avant-garde without Words*), Iwanami shinsho 104. Tokyo: Iwanami shoten, 1990.

Curatorial Department of Nezu Institute of Fine Arts. *Nezu Bijutsukan zō hin sen: Cha no bijutsu hen* (*Catalogue of Selected Masterpieces from the Nezu Collections: The Art of Tea*). Tokyo: Nezu Institute of Fine Arts, 2001.

Hayashiya Tatsusaburō et al. *Kadokawa Chadō Daijiten* (*Kadokawa Dictionary of The Way of Tea*). 2 vols. Tokyo: Kadokawa shoten, 1990.

Matsuoka Shinpei. *Utage no shintai: Basara kara Zeami e* (*Form and Body in Banquets: From Basara to Zeami*). Tokyo: Iwanami Shoten, 2004.

Moriya Takeshi. *Nihon Chūsei e no shiza: Furyū, basara, kabuki* (*Viewpoints on Japan's Medieval Period: Furyū, Basara, Kabuki*), NHK bukkusu 459. Tokyo: Nihon hōsō shuppan kyōkai, 1984.

Murai Yasuhiko. *Cha no bunkashi* (*Cultural History of Tea*). Tokyo: Iwanami shoten, 1979.

Nagashima Fukutarō. *Chūsei bunkajin no kiroku: Chakaiki no sekai* (*Journals of Medieval Aesthetes: The World of Tea Records*). Kyoto: Tankō sha, 1972.

Nishiyama Matsunosuke. "Chashaku no rekishi" (The history of tea scoops). In *Cha no Dōgu* (Tea Utensils) 2: *Chawan, Chashaku, Chaki* in the series *Chadō Shūkin* (*Exemplary Collections for the Way of Tea*) 11. Tokyo: Shōgakukan, 1983.

Senke Jisshoku (*Ten Craft Houses for the Sen Family*), *Tankō bessatsu* (*Tankō Special Issue*) 21. Kyoto: Tankōsha, 1997.

Tokugawa Art Museum and Gotoh Art Museum. *Chanoyu meiwan: Aratanaru Edo no bi no ishiki* (*Master Tea Bowls: The Aesthetics of the Edo Period*). Nagoya Tokugawa Art Museum; Tokyo: Gotoh Art Museum, 2005.